✆ AN OBSERVER'S GUIDE

British Paintings of the Nineteenth Century

The **Where is it?** Series provides a guide to the location of major European works of art that are on view to the public in most places throughout the world.

The arrangement of the 'Contents' in this and in most titles in the series has been designed to enable readers to locate the works of any artist in whom they are interested, and *also* to find out easily what paintings are on view in any specific place.

⊖ OBSERVER'S GUIDES

Home and Garden

The Herb Grower's Guide
Car Care

Art and Craft

Pencil Drawing
Drawing with Ink
Using Pastels
Beginning Watercolour
Materials and Techniques of Oil Painting
Materials and Techniques of Watercolour
Materials and Techniques of Acrylic Painting
Materials and Techniques of Collage
Let's Make Pottery
First Steps in Upholstery—Traditional Handmade

Where Is It?

British Paintings—Hogarth to Turner
European Paintings of the 18th Century
Twentieth Century Paintings—Bonnard to Rothko
Italian, French and Spanish Paintings of the 17th Century
British Paintings of the 19th Century
Paintings and Sculptures of the 15th Century
European Paintings of the 19th Century
Dutch and Flemish Paintings of the 17th Century

British Paintings
of the Nineteenth Century

Catherine Gordon

FREDERICK WARNE

Published by Frederick Warne (Publishers) Ltd, London, 1981

Acknowledgement

The author and publishers thank the Phaidon Press Limited for permission to reproduce in this book a number of biographies contributed by Catherine Gordon to *Painting in Britain 1525–1975* by John Sunderland, of which Phaidon Press Limited owns the copyright.

ISBN 0 7232 2420 X

Printed and bound in Great Britain by
Butler & Tanner Ltd, Frome and London
1621.681

CONTENTS

I List of British 19th-Century Painters and where to see their Major
 Works ... 1
 ▬ Artists' names listed alphabetically
 ▬ Biographical note, and critical description of each artist's work
 ▬ Paintings listed according to the country, town and institution
 where they are held

II The Topographical Index 81
 ▬ Arranged alphabetically, country by country
 ▬ Towns and institutions listed alphabetically within each country
 section

Author's Explanatory Notes

The list offers a selection of representative 19th-century British artists. All the artists included were born between 1788 and 1859, and (with the single exception of R. P. Bonington who died very young) all worked and exhibited in Britain during the reign of Queen Victoria.

The lists are not intended to be comprehensive, but to offer a characteristic selection of each artist's work. It should *not* be assumed that any specific item is on regular exhibition without checking with the institution concerned.

The majority of the listed works are in oil, but some works in watercolour, tempera, gouache, fresco and mixed media are included.

Where a painting has acquired a second name, both are given; the correct title first, and the popular one following it in brackets, eg, *Our English coasts (Strayed sheep)*.

Where more than one authentic variant of a composition exists, the word 'version' is given after the title.

Catherine Gordon 1981

LAWRENCE ALMA-TADEMA b. Dronrijp 1836-d. Wiesbaden 1912

Born in Holland of Dutch parents, Alma-Tadema studied at the Antwerp
Academy and later with Baron Hendrik Leys. Although he initially painted
subjects from medieval history, after visiting Italy in 1863 he devoted the rest
of his career to imaginary scenes from classical Greece, Rome and ancient
Egypt, which combine dedicated attention to archaeological accuracy and
luminous treatment of marble and rich metals with an interpretation of the
classical world as a hedonistic dream. Alma-Tadema gave all his finished
pictures opus numbers in Roman numerals and, after settling in London in
1870, he even designed his house (now demolished) in St John's Wood in the
style of a Pompeian villa. His painting *The Roses of Heliogabalus* is in a private
collection.

Australia
Adelaide, Art Gallery of South Australia	*'Nobody asked you sir!' she said*
Melbourne, National Gallery of Victoria	*The vintage festival*
Sydney, Art Gallery of New South Wales	*Cleopatra*

Belgium
Antwerp, Koninklijk Museum voor Schone Kunsten	*Cherries*

Germany, West (FDR)
Hamburg, Hamburger Kunsthalle	*The vintage festival*
	Fishing
	An antique custom
	A dedication to Bacchus

Great Britain
Aberdeen, Art Gallery	*A garden altar*
	Self-portrait
Birkenhead, Williamson Art Gallery	*Lady Alma-Tadema, the artist's wife*
Birmingham, City Art Gallery	*Phidias and the Parthenon*
	Autumn – vintage festival
Brighton, Art Gallery	*A secret*
	The proposal: courtship
Bristol, City Art Gallery	*Unconscious rivals*
Burnley, Towneley Hall Art Gallery	*A picture gallery in Rome at the time of Augustus*
Buscot Park (National Trust)	*Impatience*
Cambridge, Fitzwilliam Museum	*94 degrees in the shade*
Cardiff, National Museum of Wales	*Prose*
	Poetry
Glasgow, Art Gallery	*A Roman art lover (Silver statue)*
Kilmarnock, Dick Institute	*An audience at Agrippa's*

Liverpool, Sudley Art Gallery	*There he is!*
	Sunday morning
London, Fulham Public Library	*Pomona festival*
	Interrupted
London, Guildhall Art Gallery	*Pleading*
	The Pyrrhic dance
	At the wineshop
London, National Portrait Gallery	*Rt. Hon. Arthur James Balfour*
London, Royal Academy of Arts	*Improvisatore*
	Family group
	The way to the Temple
	Ernest Waterlow, R.A.
London, Tate Gallery	*A foregone conclusion*
	A silent greeting
	A priestess of Apollo
	Sunday morning; the two sisters
	A favourite custom
London, Victoria and Albert Museum	*The visit; Sunday morning before churching*
Manchester, City Art Gallery	*A Roman flower market*
	Pompeii
	Silver favourites
Newcastle, Laing Art Gallery	*Love's votaries; love in idleness*
Oxford, Ashmolean Museum	*A hearty welcome*
Port Sunlight, Lady Lever Art Gallery	*In the tepidarium*
	The favourite poet
Preston, Harris Art Gallery	*Pastimes in ancient Egypt 3000 years ago*
Walthamstow, William Morris Gallery	*The dinner*
	Miss Thackeray's 'Elizabeth'
	In the time of Constantine

Netherlands

Amsterdam, Rijksmuseum	*An Egyptian widow*
	The death of the first-born
Amsterdam, Historisches Museum	*Emperor Hadrian's visit to a British pottery*
Dordrecht, Dordrechts Museum	*Venantius Fortunatus reading his poems to Radagonda*
Groningen, Groninger Museum voor Stad en Lande	*My family; the aesthetic view, Mde Dumoulin, Pauline and Laurence*
The Hague, Haags Gemeentemuseum	*Tine Son-Maris*
The Hague, Rijksmuseum H.W. Mesdag	*The embarkation*
	Study for Mrs H. W. Mesdag
	Spring in the gardens of the Villa Borghese
Laren, Singer Museum	*A peep through the trees*
Leeuwarden, Fries Museum	*Self-portrait*
	The artist's mother

Soestdijk, Koninklijk Huisarchief,
 Soestdijk Palace

Queen Fredegonda at the deathbed of
 Bishop Praetextatus
Interior of San Clemente, Rome
A Romano-British pottery
Reflections: fishing

New Zealand

Auckland, City Art Gallery

Cleopatra
Fishing

South Africa

Johannesburg, Art Gallery

The sad father, or the unfortunate oracle
 (Death of the first-born)

USA

Baltimore, Walters Art Gallery

An audience
Not at home
The triumph of Titus: the Flavians
Sappho and Alcaeus
A Roman emperor

Boston, Museum of Fine Arts

Promise of spring
Tibullus at Delia's
Woman and flowers

Cambridge, Fogg Art Museum

The tragedy of an honest wife

Cincinnati, Art Museum

Comparisons

Cincinnati, Taft Museum

A world of their own

Malibu, J. Paul Getty Museum

Spring

Milwaukee, Milwaukee Art Center

Roman art lover (The runner)

New Haven, Yale University Art
 Gallery

A Roman art lover

Philadelphia, Museum of Art

A reading from Homer

Poughkeepsie, Vassar College Art
 Gallery

An exedra

Williamstown, Clark Art Institute

Hopeful

RICHARD PARKES BONINGTON b. Arnold nr Nottingham 1802–d.
London 1828

Bonington's family emigrated to France in 1817 and after early training with
François-Louis Francia, an artist experienced in the technique of English
watercolour, he studied in the Louvre and in the studio of Gros. Bonington,
who admired Constable, travelled extensively during his brief life, producing
picturesque landscapes in both oil and watercolour within an English tradi-
tion. But he also, through a close friendship with Delacroix, played an im-
portant role in the development of French romantic art, particularly in small
costume paintings depicting scenes of historical incidents. Only oils are listed.

Australia

Melbourne, National Gallery of
 Victoria

Boulogne – low tide

4 BONINGTON

Canada
Montreal, Museum of Fine Arts

Ottawa, National Gallery of Canada

The cavalier
View of the south coast of England
Landscape with a waggon
Le Palais des Doges

France
Paris, Louvre

Versailles – vue du parterre d'eau
Venice – the Ducal Palace from the Riva Degli Schiavoni
François I and the Duchesse d'Etampes
Anne d'Autriche and Mazarin

Great Britain
Anglesey Abbey (National Trust)
Cambridge, Fitzwilliam Museum
Edinburgh, National Gallery of Scotland
Hull, Ferens Art Gallery
Liverpool, Sudley Art Gallery
London, Tate Gallery

London, Victoria and Albert Museum
London, Wallace Collection

Manchester, City Art Gallery

Nottingham, Castle Museum

Mouth of the Somme
Landscape with a pond
Landscape with mountains
Venice – Grand Canal
Coast scene in Picardy
Fishing boats in a calm
Venice – Ducal Palace with a religious procession
The Column of St Mark's, Venice
Near Boulogne
The Pont des Arts, Paris
River scene – sunset

A child at prayer
Bergues, near Dunkirk
Francois I and Marguerite de Navarre
Henri III and the English ambassador
Anne Page and Slender
The Seine near Mantes
On the coast of Picardy
Henri IV and the Spanish ambassador
Landscape, with timber waggon, France
The Piazza San Marco, Venice
Pays de Caux, twilight
View in Brittany, bridge, cottage and washerwomen
Venice – Grand Canal with Santa Maria della Salute
Fisherfolk on the Normandy coast
Don Quixote in his study
Quentin Durward in Liège
St Bertin near St Omer, transept of the abbey
A large collection of drawings, water-colours and engravings

| Oxford, Ashmolean Museum | *Amy Robsart and the Earl of Leicester* |
| Sheffield, City Art Galleries | *The Piazzetta, Venice* |

Greece

| Athens, Benaki Museum | *The Count of Palatiano in the costume of a palikar* |

South Africa

| Johannesburg, Art Gallery | *Landscape in Normandy* |

USA

Boston, Museum of Fine Arts	*The use of tears*
Chicago, Art Institute of Chicago	*Francis I and Marguerite of Navarre*
New Haven, Yale Center for British Art	*A fish market, Boulogne*
	In the Forest of Fontainebleau
New York, Metropolitan Museum of Art	*Roadside halt*
	Mantes on the Seine
	Château of the Duchesse de Berri
Philadelphia, Museum of Art	*Coast scene, Normandy*
Richmond, Virginia Museum of Fine Arts	*View on the Seine*

FRANK BRAMLEY b. Sibsey, near Boston 1857–d. London 1915

After training at Lincoln School of Art and Verlat's Academy in Antwerp, Bramley initially worked in Venice but by 1885 he had joined the community of artists living in Newlyn, Cornwall, which included Forbes (q.v.) Langley, Tuke, and Gotch. Bramley, notably in his famous *Hopeless Dawn* of 1888, was an exponent of the 'square brush' technique, and combined the social concerns of an artist such as Holl (q.v.) with the *plein-air* approach of Bastien-Lepage. Elected ARA in 1894 and full Academician in 1911, Bramley was also a founder member of the New English Art Club.

Great Britain

Grasmere, Village Hall	*Grasmere rushbearing*
Lincoln, Usher Art Gallery	*Weaving nets*
	Neapolitan fisher boy
Liverpool, Walker Art Gallery	*Among the roses*
London, Royal Academy of Arts	*Confidences*
London, Tate Gallery	*A hopeless dawn*

Ireland, Republic of

| Cork, Municipal Art Gallery | *Domino* |

New Zealand

| Auckland, City Art Gallery | *'For of such is the kingdom of heaven'* |

South Africa

| Cape Town, South African National Gallery | *After fifty years* |
| Durban, Art Gallery | *Saved* |

JOHN BRETT b. Bletchingley, Surrey 1830–d. Putney 1902

After studying at the RA schools and visiting Switzerland, Brett was attracted towards the Pre-Raphaelite style by the mid 1850s. Following the exhibition of *The Stonebreaker* in 1858, Brett was taken up by Ruskin, who encouraged him to concentrate on landscape, accompanied him to Italy and pushed the artist towards that almost obsessive concentration on geological precision which is a characteristic of his style. Brett's later works were exclusively landscapes, usually of coasts and cliffs, and they became increasingly intense in colour. *The Val d'Aosta*, of which Ruskin wrote 'I never saw the Mirror so held up to nature' is in a private collection.

Great Britain

Aberdeen, Art Gallery	*Isles of Skomer and Skokholm*
	Self-portrait
Birmingham, City Art Gallery	*A north-west gale off the Longships Lighthouse*
	Caernarvon
	February in the Isle of Wight
	Near Sorrento
Brighton, Museum and Art Gallery	*Watergate, Cornwall*
Cambridge, Fitzwilliam Museum	*Rocky coastal landscape*
	Landscape
Egham, Royal Holloway College	*Carthillon Cliffs*
Exeter, Royal Albert Memorial Museum	*The home of the gull*
Glasgow, Art Gallery	*St Ives Head*
Liverpool, Walker Art Gallery	*Trevose Head*
	The stonebreaker
	Rocks, Scilly
London, Guildhall Art Gallery	*Echoes of a far-off storm*
London, National Maritime Museum	*Britannia's realm*
London, Tate Gallery	*Britannia's realm*
	Glacier at Rosenlaui
	Florence from Bellosguardo
	Lady with a dove, Madame Loeser
	The British Channel seen from the Dorsetshire Cliffs
Manchester, City Art Gallery	*The Norman Archipelago*
	Seascape
Nottingham, Castle Museum	*Golden prospects, St Catherine's Well, Land's End, Cornwall*
Plymouth, City Art Gallery	*Cattewater, Plymouth*
	Drake's Island
Sheffield, City Art Galleries	*Mount Etna from Taormina*
Sunderland, Art Gallery	*A procession of craft up to Bristol in a fog*
Wightwick Manor (National Trust)	*Scag Rock*
	Land's End, Cornwall

Ireland, Republic of
Dublin, National Gallery of Ireland *Felixstowe*

South Africa
Johannesburg, Art Gallery *Mount's Bay, Cornwall*

USA
Indianapolis, Museum of Art *Massa, Bay of Naples*

FORD MADOX BROWN b. Calais 1821–d. London 1893

Brown studied at various Belgian academies and with Baron Gustaf Wappers
(1837–39) and he lived in Paris until 1844. He exhibited in London from 1841
and after competing in the Westminster Palace decorations scheme (1844–45)
he settled in London in 1846. Visiting Rome in 1845 he had been impressed,
like Dyce (q.v.), by the German Nazarene painters. Brown painted historical,
literary and biblical subjects throughout his career, but, after accepting
Rossetti (q.v.) as a pupil in 1848 he came under the influence of the Pre-
Raphaelites. Though older than the other artists and never a member of the
Brotherhood, he was associated with them in the early 1850s and painted
social themes from modern life such as *The Last of England* and *Work*. Towards
the end of his life (1881–87) he painted a series of frescoes on British history
in Manchester Town Hall.

Australia
Melbourne, National Gallery of *The Entombment*
 Victoria *Haidee and Don Juan*
Sydney, National Gallery of New *Chaucer in the Court of Edward III*
 South Wales

Great Britain
Aberdeen, Art Gallery *The Romans building Manchester*
Birmingham, City Art Gallery *The last of England*
 Work (small version)
 Pretty baa-lambs
 An English autumn afternoon
 Walton-on-the-Naze
 The death of Sir Tristram
 Elijah and the widow's son
 The finding of Don Juan by Haidee
 Wycliffe on his trial (unfinished)
Bradford, Cartwright Hall *Wycliffe reading his translation of the*
 Bible to John of Gaunt in the presence
 of Chaucer and Gower
Buscot Park (National Trust) *The Entombment*
Cambridge, Fitzwilliam Museum *Cordelia's portion*
 The last of England (1860 version)
Carlisle, Art Gallery *The baptism of St Edwin AD 627*
 Windermere
Glasgow, Art Gallery *Wycliffe on trial*

Liverpool, Walker Art Gallery	*The coat of many colours*
London, Tate Gallery	*'Take your son, Sir'* (unfinished)
	Lear and Cordelia
	The last of England (version)
	Carrying corn
	The Brent at Hendon
	Chaucer at the Court of Edward III (version)
	The hayfield
	Platt Lane
	Jesus washing Peter's feet
Manchester, City Art Gallery	*Work*
	William Shakespeare
	Cromwell, Protector of the Vaudois
	The body of Harold brought before William the Conqueror
	Stages of cruelty
	The prisoner of Chillon
	Dr Primrose and his daughters
	Rev. F. H. S. Pendleton
	Manfred on the Jungfrau
	Study for 'Work': Heath St, Hampstead
	The traveller
	Iron, Weaving, Shipping, Spinning, Commerce, Corn, Wool (decorations for the Royal Jubilee Exhibition, 1887)
	Study of a courtier, from 'Chaucer at the Court of Edward III'
	The English boy
	Madelaine Scott
	Byron's dream
	Out of town (*Morning walk*)
	The Bromley family
Manchester, Town Hall	Set of murals:
	The Romans building a fort at Mancenion
	The baptism of Edwin
	The expulsion of the Danes from Manchester
	The establishment of the Flemish weavers in Manchester
	The trial of Wycliffe
	The proclamation regarding weights and measures
	Crabtree watching the transit of Venus
	Chatham's life dream
	Bradshaw's defence of Manchester

	John Kay, inventor of the fly-shuttle *The opening of the Bridgewater Canal* *Dalton collecting marsh-fire gas*
Nottingham, Castle Museum	*Cromwell and the Vaudois*
Oxford, Ashmolean Museum	*The pretty baa-lambs (Summer's heat)* (version) *Study for the execution of Mary Queen of Scots* *The Seeds and Fruit of English Poetry* (first version) *Mrs Madox*
Port Sunlight, Lady Lever Art Gallery	*Cordelia's portion* *Cromwell on his farm* *Windermere*
Southampton, Art Gallery	*King Lear and Cordelia* (1875 version)
Stratford, Royal Shakespeare Theatre Picture Gallery	*William Shakespeare* *Mathilde Blind*
Walthamstow, William Morris Gallery	*Windermere*
Wightwick Manor (National Trust)	*William Michael Rossetti by gaslight* *Jane Morris* (head by Rossetti)

South Africa

Johannesburg, Art Gallery	*Cromwell on his farm* *Ehud killing King Eglon*

USA

Cambridge, Fogg Art Museum	*Self-portrait*
Wilmington, Delaware Art Museum	*Hampstead Heath from the artist's window* *Romeo and Juliet* *The Corsair's return*

EDWARD COLEY BURNE-JONES b. Birmingham 1833–d. Fulham 1898

Burne-Jones planned to enter the church, but he met William Morris while at Oxford, and a shared enthusiasm for medieval romance and chivalry, epitomized by the works of Sir Thomas Malory, combined with an excited response to Pre-Raphaelite painting, led to his decision to dedicate himself to art. His decorative individual style was originally influenced by Rossetti (q.v.), who accepted him as a pupil; but after 1862 Burne-Jones' paintings become larger and more monumental, suggesting his interest in Botticelli, Mantegna and Michelangelo. His subject matter was drawn from myth and legend, from which he created a dream-like world of statically graceful figures which was important in the development of the Aesthetic Movement and Art Nouveau design. Burne-Jones frequently designed tapestries and stained glass for Morris, Marshall, Faulkner and Company, but he did not, like William Morris, consider his art as a means of social reform; rather he wrote 'I have learned to know beauty when I see it and that's the best thing'.

Australia

Adelaide, Art Gallery of South Australia	*Perseus and Andromeda*
Brisbane, Queensland Art Gallery	*Aurora*
Melbourne, National Gallery of Victoria	*The garden of Pan*
	The wheel of fortune
Sydney, Art Gallery of New South Wales	*The fight: St George kills the dragon*

Germany, West (FDR)

Stuttgart, Staatsgalerie	*Perseus and the Graeae*
	The rock of doom
	The doom fulfilled
	The baleful head

Great Britain

Birkenhead, Williamson Art Gallery	*Pyramus and Thisbe triptych*
Birmingham, City Art Gallery	*The Annunciation*
	Pygmalion and the Image:
	The heart desires
	The hand refrains
	The Godhead fires
	The soul attains
	The story of Cupid and Psyche: decorations for No. 1 Palace Green, Kensington (12 paintings)
	The feast of Peleus
	The wizard (unfinished)
	The backgammon players
	Phyllis and Demophoon
	Helen captive in burning Troy
	King Mark and La Belle Iseult
	The merciful Knight
	The idyll
	A large collection of watercolours and drawings
Bristol, City Art Gallery	*St George and the dragon: the return*
	The garden court
Burnley, Towneley Hall Art Gallery	*Wood nymphs*
Buscot Park (National Trust)	*The Briar Rose series:*
	The rose bower
	The garden court
	The council room
	The briar wood
Cardiff, National Museum of Wales	*Venus discordia*
	The wheel of Fortune
Carlisle, Art Gallery	*Helen, a mermaid*
	The goldfish pool
	The Three Graces

Compton, Watts Gallery	*The triumph of Love*
Falmouth, Art Gallery	*Study for The Car of Love*
	Study for The Knight in the Briar Rose
	Study for The Masque of Cupid
Glasgow, Art Gallery	*Danae and the Brazen Tower*
	The angel
Leicester, City Art Gallery	*Christ and the Twelve Apostles*
Liverpool, Sudley Art Gallery	*An angel playing a flageolet*
Liverpool, Walker Art Gallery	*The sleeping knights*
	Sponsa di Libano
London, Fulham Public Library	*Morgan le Fay*
	A girl tending flowers
	Cupid delivering Psyche
	The wheel of Fortune
London, Leighton House	*Sir Lancelot at the Chapel of the Holy Grail*
	Sir Percival and Sir Bors at the Chapel of the Holy Grail
London, Tate Gallery	*Love leading the pilgrim*
	King Cophetua and the beggar maid
	Triptych: Adoration of the Kings; the Shepherds; the Annunciation
	The golden stairs
	The morning of the Resurrection
	The Temple of Love (unfinished)
	A large collection of drawings and watercolours
London, Victoria and Albert Museum	*The mill: girls dancing to music by a river*
	The Car of Love (Love's wayfaring)
	Merlin and Nimue
	A Scene from 'Roman de la Rose'
Manchester, City Art Gallery	*Sibylla delphica*
Newcastle, Laing Art Gallery	*Laus Veneris*
Norwich, Castle Museum	*The Annunciation*
Oxford, Ashmolean Museum	*The building of the brazen tower*
	Love leading Alcestis
	The two wives of Jason, Hypsipyle and Medea
Plymouth, City Art Gallery	*Venus concordia* (unfinished)
Port Sunlight, Lady Lever Art Gallery	*The beguiling of Merlin*
	The Annunciation
	The Tree of forgiveness: Phyllis and Demophoon
Sheffield, City Art Galleries	*The guitar player*
	The hours
	Cupid delivering Psyche
	The mandolin player
Southampton, Art Gallery	*Lancelot at the Chapel of the Holy Grail*

The arming of Perseus
Perseus and the Graeae
Perseus in the garden of the nymphs
Perseus about to sever the head of Medusa
The escape of Perseus
Atlas turned to stone
Perseus slaying the serpent (The doom fulfilled)
The rescue of Andromeda (The rock of doom)
Perseus and his bride (The baleful head)
The birth of Pegasus and Chrysaor from the blood of Medusa

Wallington Hall (National Trust) — *Idleness and the pilgrim of Love*
Walthamstow, William Morris Gallery — *The lament*

Wightwick Manor (National Trust) — *Love among the ruins* / *Pomona*

Ireland, Republic of
Dublin, Municipal Gallery of Modern Art — *The sleeping princess*

New Zealand
Auckland, City Art Gallery — *The Car of Love*
Dunedin, Public Art Gallery — *Hope*
Wanganui, Sarjeant Art Gallery — *Thisbe* / *Fountain of Youth*

Puerto Rico
Ponce, Museo de Arte — *The sleep of King Arthur in Avalon*
The Small Briar Rose series:
 The prince entering the briar wood
 The king and courtiers asleep
 The princess and maidens asleep

USA
Boston, Museum of Fine Arts — *Cinderella*
Cambridge, Fogg Art Museum — *Day* / *Night* / *The depths of the sea*
Hartford, Wadsworth Atheneum — *St George*
New Haven, Yale Center for British Art — *Queen Eleanor and the Fair Rosamond*
New York, Metropolitan Museum of Art — *Chant d'amour*
Wilmington, Delaware Art Museum — *'The Prioress's Tale'* / *The council chamber (Briar Rose series)* / *Study for Nimue in The beguiling of Merlin*

LADY ELIZABETH SOUTHERDEN BUTLER b. Lausanne 1846–d. London 1933

After studying at the South Kensington Schools and in Italy, Lady Butler (née Thomson) became famous when her painting *Calling the Roll after an Engagement, Crimea* (R.A. 1874) was bought by Queen Victoria. Her works, which were frequently engraved, display heroic and patriotic military incidents and combine lively draughtsmanship of horses with precise attention to uniform and regimental tradition much appreciated by the army. Her paintings, praised by Ruskin for 'graduations of colour and shade of which I have not seen the like since Turner's death' share the British imperial assur-ance of the poetry of Kipling and Newbolt. *The Roll Call* and *The Defence of Rorke's Drift*, both owned by H.M. the Queen, are lent to Camberley Staff College.

Australia
Melbourne, National Gallery of Victoria — *Quatre Bras*

Great Britain
Bury, Art Gallery — *Listed for the Connaught Rangers*
Hull, Ferens Art Gallery — *Return from Inkermann*
Leeds, City Art Gallery — *Scotland for ever!* (*The Scots Greys at Waterloo*)
London, Tate Gallery — *The remnant of an army* (lent to Taunton)
Manchester, City Art Gallery — *Balaclava* (*The return*)
Nottingham, Castle Museum — *Preliminary drawing for Inkerman*

South Africa
Durban, Art Gallery — *In the retreat from Mons*

GEORGE CLAUSEN b. London 1853–d. Newbury 1944

Clausen trained at the South Kensington Schools while acting as assistant to Edwin Long (q.v.). In 1875–76 he visited Holland and Belgium, where he briefly attended the Antwerp Academy, and later he studied in Paris. Clausen painted landscapes and portraits but specialized in rustic themes, often from the lives of Essex rural labourers, which convey a mood of reflective calm. Fascinated by the effects of light, he painted out of doors in a naturalist style influenced by Millet and Bastien-Lepage. Clausen was a founder member of the New English Art Club, professor of painting at the RA 1904–6, and was elected RA in 1908.

Australia
Adelaide, Art Gallery of South Australia — *The rickyard, winter idyll* / *October morning*
Brisbane, Queensland Art Gallery — *The avenue*
Melbourne, National Gallery of Victoria — *The ploughman's breakfast* / *Frosty morning: the houses at the back*

Perth, Art Gallery of Western Australia	*The end of a long day*
Sydney, Art Gallery of New South Wales	*Propping the rick – stormy day* *Interior with reading girl* *Watson's barn*

Canada

Ottawa, Canadian War Museum	*Return to the reconquered land*
Toronto, Art Gallery of Ontario	*Haytime*

Great Britain and Northern Ireland

Aberdeen, Art Gallery	*Ploughing*
Belfast, Ulster Museum	*Sunrise on the road*
Birmingham, City Art Gallery	*Building the rick* *Boy cutting off a stick*
Bradford, Cartwright Hall	*The boy and the man* *Winzes farm*
Bristol, City Art Gallery	*The flower* *An artist painting out of doors* *Agriculture*
Bury, Art Gallery	*A spring morning – Haverstock Hill*
Cambridge, Fitzwilliam Museum	*Self-portrait 1918*
Cardiff, National Museum of Wales	*In the fields in June* *Apple blossom* *Girl in a field* *Clavering Church*
Edinburgh, National Gallery of Scotland	*The stars coming out*
Glasgow, Art Gallery	*La pensée*
Huddersfield, Art Gallery	*The High Royd murals:* *The golden age* *Harvest* *Evening* *Morning*
Hull, Ferens Art Gallery	*Sunrise in September*
Leeds, City Art Gallery	*Souvenir of Marlow Regatta* *The road to Tilty* *At the back of the barn* *The valley* *The miller's man* *Daffodils* *In the barn* *Reading by lamplight (Twilight interior)* *The shy girl* *A little girl* *Girl in black* *Pinks and pansies* *The village at night* *The village green at night*

	Misty morning
	The farmyard
	The gap in the hedge
	Green fields
Lincoln, Usher Art Gallery	*The mowers*
	A. G. Webster
	Orchard scene
Liverpool, Walker Art Gallery	*The shepherdess*
	Kitty
	A straw plaiter
	The golden barn
London, Imperial War Museum	*Youth mourning*
	In the gun factory, Woolwich Arsenal, 1918
London, Leighton House	*The blacksmith*
London, Royal Academy of Arts	*Interior of an old barn*
London, St Stephen's Hall, Palace of Westminster	*The English people gathering secretly to read Wycliffe's Bible*
London, Tate Gallery	*Girl at the gate*
	Brown eyes
	The gleaners returning
	My back garden
	A dancer
	A frosty March morning
	The road, winter morning
London, Victoria and Albert Museum	*Breton girl carrying a jar*
Manchester, City Art Gallery	*The old reaper*
	Girl's head
	Winter morning
Newcastle, Laing Art Gallery	*Contemplation*
	The stone pickers
	Dusk
Nottingham, Castle Museum	*High Mass at a fishing village on the Zuyder Zee*
Oldham, Art Gallery	*Phyllis*
Oxford, Ashmolean Museum	*Head of a peasant boy*
Preston, Harris Art Gallery	*Bird scaring, March*
Rochdale, Art Gallery	*The golden barn*
Stoke-on-Trent, Art Gallery	*A Normandy Peasant*
	Rickyard, morning

New Zealand

Auckland, City Art Gallery	*In the small hours*
Wellington, National Gallery of New Zealand	*The haymakers*

South Africa

Cape Town, South African National Gallery	*The window*
	Evening on the moorland

Durban, Art Gallery	*Harvest in the bean field*
	Interior of a barn
Johannesburg, Art Gallery	*A morning in June – Summer's Day*
	The breakfast table
Pietermaritzburg, Tatham Art Gallery	*Boy threshing*

THE HON. JOHN COLLIER b. London 1850–d. London 1934

A younger son of Lord Monkswell, Collier trained at the Slade School of Art under Poynter (q.v.) and later studied in Paris and Munich. A successful society portraitist he is particularly remembered now as a painter of 'problem pictures' – paintings which, in a manner popularized by Orchardson (q.v.), showed scenes of psychological drama – moments of conflict or anxiety drawn from history or modern life.

Australia
| Adelaide, Art Gallery of South Australia | *Priestess of Delphi* |
| Sydney, Art Gallery of New South Wales | *The lute player* |

Great Britain
Batemans (National Trust)	*Rudyard Kipling*
Birkenhead, Williamson Art Gallery	*Montana*
	Vendetta
Blackburn, Art Gallery	*Hetty Sorrel*
Blackpool, Grundy Art Gallery	*The amber necklace*
Bournemouth, Russell-Cotes Art Gallery	*Lewis Waller as Monsieur Beaucaire*
Bradford, Cartwright Hall	*Queen Guinevere's maying*
Coventry, Herbert Art Gallery	*Lady Godiva*
Darlington, Art Gallery	*Brotherhood of Man*
Glasgow, Art Gallery	*The death of Albine*
Gloucester, Art Gallery	*Gloucester docks*
Ipswich, Christchurch Mansion	*A glass of wine with Caesar Borgia*
Lincoln, Usher Art Gallery	*The prodigal daughter*
London, Guildhall Art Gallery	*Clytemnestra*
London, National Portrait Gallery	*Charles Darwin*
London, Tate Gallery	*The last voyage of Henry Hudson*
Merthyr Tydfil, Cyfantha Castle Art Gallery	*Mariage de convenance*
Oldham, Art Gallery	*The death of Cleopatra*
Plymouth, City Art Gallery	*Mrs Mortimer Collier and family*
	Self-portrait c. 1932
Southampton, Art Gallery	*Lady Darling*
Southport, Atkinson Art Gallery	*In the Venusburg (Tannhäuser)*
Stoke-on-Trent, Art Gallery	*Brotherhood of Man*
Sunderland, Art Gallery	*Theban Hills from Luxor*

Wakefield, City Art Gallery	*Mother of pearl*
Wolverhampton, Art Gallery	*Sentence of death*
Worcester, Art Gallery	*Clytemnestra*

Ireland, Republic of

Dublin, National Gallery of Ireland	*George Bernard Shaw*

New Zealand

Auckland, City Art Gallery	*The fallen idol*

WILLIAM COLLINS b. London 1788–d. London 1847

Collins attended the RA schools 1807–14 where he became a close friend of Wilkie. He was elected RA in 1820. Though he travelled widely in Europe and spent two years in Italy (1836–38), his paintings are mostly scenes of English rural life within a tradition established by Morland and often show coastal landscapes with incidents involving children. *The Sale of the Pet Lamb* (1813: private collection) was the characteristic sentimental painting which first made him famous.

Great Britain

Accrington, Haworth Art Gallery	*Cottage hospitality*
Birmingham, City Art Gallery	*The reluctant departure*
Bournemouth, Russell-Cotes Art Gallery	*Children playing with puppies*
Brighouse, Art Gallery	*The shrimpers*
Bury, Art Gallery	*The minnow catchers*
	The cherry seller – scene at Turvey, Bedfordshire
Chatsworth (Duke of Devonshire)	*Rustic civility (Coming events)*
Cheltenham, Art Gallery	*The sale of the pet calf*
Egham, Royal Holloway College	*Borrowdale, Cumberland, children playing by the banks of a brook*
Gateshead, Shipley Art Gallery	*The return of the fishing boats*
Leeds, City Art Gallery	*The world or the cloister*
Liverpool, Sudley Art Gallery	*Poor travellers at the door of a Capuchin convent*
Liverpool, Walker Art Gallery	*Returning from the haunts of the sea-fowl*
London, Guildhall Art Gallery	*The pet lamb*
	Borrowdale
	The kitten deceived
	Barmouth Sands
	The nutting party
London, Royal Academy of Arts	*The young anglers*
London, Tate Gallery	*Sunday morning*
	Cromer Sands
	The prawn catchers
	As happy as a king (version)

London, Victoria and Albert Museum	*The caves of Ulysses at Sorrento* *The garden of the Villa d'Este* *Hall Sands, Devonshire* *The stray kitten* *Fisherwoman on the coast at Boulogne* *Rustic civility* (version) *Seaford, coast of Sussex*
Manchester, City Art Gallery	*The cottage door*
Nottingham, Castle Museum	*The withered tree* *Taking out the thorn*
Preston, Harris Art Gallery	*The mariner's widow*
Sheffield, City Art Galleries	*Cromer Sands*
Southport, Atkinson Art Gallery	*A girl of Sorrento spinning*
Wolverhampton, Art Gallery	*Children gathering seaweed* *At the cottage gate* *The carrier's resting place* *The village gossip*

Ireland, Republic of

Dublin, National Gallery of Ireland	*The Artist's mother* *Irish coast*

USA

New Haven, Yale Center for British Art	*The Thames near Richmond, a frost scene* *Donkeys and figures on a beach*
Williamstown, Clark Art Institute	*Children on a beach*

RICHARD DADD b. Chatham 1817–d. Broadmoor Hospital 1887

Dadd is unfortunately most renowned because of his insanity, which led to his murdering his father in 1843 and being confined for the rest of his life, first in Bethlem Hospital and from 1864 in Broadmoor. He entered the RA schools in 1837 where with Egg, Frith (qq.v.) and others he belonged to a loose grouping of artists calling themselves 'The Clique' who encouraged each other in the search for original subject matter. While beginning to establish himself as a painter of literary and fairy themes, Dadd travelled in Greece and the Middle East (1842–43), but after his return began to display increasing signs of madness. The works painted in hospital, which include fairy subjects and a series of very personalized watercolours illustrating the Passions, were painted very slowly with meticulous detail and display bizarre obsessive qualities. As well as providing insights to his psychological state, his work also shows a professional artist, deprived for over forty years of visual stimuli, seeking to use and re-use every scrap of his visual heritage and memory; and recurrent motifs can be traced from picture to picture. Both Bethlem Hospital and Broadmoor hold important collections of his work.

Great Britain

Bedford, Cecil Higgins Art Gallery	*Madonna and Child* *A hermit*

	The Flight into Egypt (Hunting scene)
Cambridge, Fitzwilliam Museum	*Songe de la fantasie*
Leeds, City Art Gallery	*A view of the ancient city of Tlos in Lycia*
Liverpool, Walker Art Gallery	*The fairy rendezvous*
London, Tate Gallery	*The Flight into Egypt*
	The fairy feller's master-stroke
	The child's problem
	A seated Turk
	Pilot boats
	Mercy: David spareth Saul's life (loan)
London, Victoria and Albert Museum	*View on the Island of Rhodes*
	Entrance to an Egyptian tomb
	Tomb of the Khalif, Cairo
	Christ walking on the water
	Idleness: Mother of Vice
	Flight of the Medea with Jason
	Fallen warrior
	Want, the malingerer
	Patriotism
	Leonidas with the woodcutters
Newcastle, Laing Art Gallery	*Reminiscence of Venice*
Newport, Museum and Art Gallery	*Splendour and wealth: Cleopatra dissolving a pearl*
Oxford, Ashmolean Museum	*Cupid and Psyche*
	Gaming
	Allegorical scene – Day, Time and Night
	Fantasie de l'hareme Egyptienne
York, City Art Gallery	*Landscape*

USA

New Haven, Yale Center for British Art	*Caravanserai at Mylasa in Asia Minor*
	Treachery
	Robin Hood
	Sailing ships
	Juvenile members of the Yacht Club
	The fish market by the sea
	Hamlet and his mother
	Negation
	Augustus Egg
	Settling the disputed point
San Marino, Huntington Art Gallery	*Dymphna Martyr*

FRANCIS DANBY b. Wexford 1793–d. Exmouth 1861

Born in Ireland, Danby studied at the Royal Dublin Society, and from 1811 settled in Bristol, where he taught drawing and painted local scenery, often including children. He moved to London 1823/4, was elected ARA in 1825 and at this period rivalled Martin (q.v.) in the painting of apocalyptic

subjects. A domestic scandal required him to leave England in 1829 and he lived mainly in Switzerland until 1841 when he returned to Exmouth. Danby's 'poetical landscapes' are precisely detailed, often with sharply rendered light effects and intense emotional serenity.

Australia

Sydney, Art Gallery of New South Wales	*The three sisters of Phaeton weeping over the tomb of their brother*

Great Britain

Bath, Victoria Art Gallery	*Study for The opening of the sixth seal*
Bristol City Art Gallery	*Clifton Rocks from Rownham Fields*
	Clifton from Leigh Wood
	The Snuff Mill, Stapleton
	Boys fishing, Stapleton Glen
	Boys sailing a little boat
	View of Blaise Castle Woods
	View of Avon Gorge
	View over Bristol from Leigh Wood
Exeter, Royal Albert Memorial Museum	*Dead calm – sunset at the Bight of Exmouth*
London, Sir John Soane's Museum	*Scene from 'The Merchant of Venice'*
London, Tate Gallery	*The Deluge, 1840*
	The wood nymph's hymn to the rising sun
London, Victoria and Albert Museum	*The enchanted castle, sunset*
	The Upas or poisoned tree of Java
	Disappointed love
	Liensfiord Lake in Norway
Preston, Harris Art Gallery	*The delivery of Israel out of Egypt – Pharaoh and his hosts overwhelmed by the Red Sea*
Sheffield, City Art Galleries	*Sunset*
	The Thames at Greenwich – misty morning
York, City Art Gallery	*The Deluge* (version)
	Sunset, a sketch

Ireland, Republic of

Dublin, National Gallery of Ireland	*The opening of the sixth seal*

Switzerland

Geneva, Musée d'Art et d'Histoire	*The baptism of Christ*
	Lake at sunset
	The baptism of Clorinda

USA

New Haven, Yale Center for British Art	*Shipwreck against a setting sun*
	Sunset on a beach at Sark
	View from Hampstead Heath, sunset
	The painter's holiday
	Landscape with heron
	Children by a brook

Landscape near Clifton
Study for Calypso's Grotto
A mountain chieftain's funeral in olden times
Swiss mountain landscape – Le Bout du Monde on the Arve

FRANCIS (FRANK) BERNARD DICKSEE b. London 1853–d. London 1928

Dicksee studied with his father, the artist Thomas F. Dicksee, before entering the RA schools, and his earlier works are scenes of chivalric romance in medieval or early renaissance costume which suggest the influence of Burne-Jones (q.v.). A fine technician, Dicksee was elected ARA in 1881 at the early age of 27, and became RA in 1891. As well as producing many society portraits, from the mid 1880s he began to paint intriguing modern subjects which hinted at emotional but elusive drama. Dicksee was elected president of the RA in 1924, although by this time younger artists found his views reactionary.

Australia

Melbourne, National Gallery of Victoria	*The crisis*

Great Britain

Aberdeen, Art Gallery	*Self-portrait*
Blackpool, Grundy Art Gallery	*A study*
Bradford, Cartwright Hall	*The mother*
	Dawn
Bristol, City Art Gallery	*La Belle Dame sans Merci*
Burnley, Towneley Hall Art Gallery	*Harmony*
Cardiff, National Museum of Wales	*A Surrey landscape*
Hull, Ferens Art Gallery	*Hon. T. R. Ferens*
Leeds, City Art Gallery	*Oriental Pastimes*
Leicester, City Art Gallery	*The Foolish Virgins: 'too late, ye cannot enter now'*
Liverpool, Walker Art Gallery	*The reverie*
	'This for Rememberance'
London, Guildhall Art Gallery	*Contemplation*
London, Royal Academy of Arts	*Startled*
London, Tate Gallery	*The two crowns*
	Harmony
Manchester, City Art Gallery	*The funeral of a Viking*
Port Sunlight, Lady Lever Art Gallery	*The magic crystal*
Preston, Harris Art Gallery	*Hesperia*
Sheffield, City Art Galleries	*Interior with a lady*
Southampton, Art Gallery	*Romeo and Juliet*
Stratford, Royal Shakespeare Theatre Picture Gallery	*Scene from 'Othello'*

WILLIAM DYCE b. Aberdeen 1806–d. Streatham, Surrey, 1864

Encouraged by Sir Thomas Lawrence, Dyce briefly attended the RA schools before in 1825 making the first of several visits to Rome where he met Cornelius and Overbeck. The ideals of these Nazarene artists, who hoped to regenerate German religious art in a style derived from Perugino and early Raphael, strongly influenced Dyce, and he also studied their revival of fresco technique. From 1837 he became increasingly involved in teaching, scholarship and administration in the government Schools of Design, and he wrote on art education and fresco technique. His work was admired by Prince Albert and he completed fresco cycles for Buckingham Palace, Osborne House and also in the Palace of Westminster where he illustrated the virtues with scenes from Malory's *Morte d'Arthur*. As an adherant of the High Church movement Dyce painted religious subjects as well as portraits and landscapes, and he was elected Royal Academician in 1848. While basing the source of his style on 15th-century Italian painting, Dyce's use of carefully-wrought detail and bright colours made him sympathetic with the Pre-Raphaelite movement.

Australia

Melbourne, National Gallery of Victoria — *Prince of Wales*

Germany, West (FDR)

Hamburg, Hamburger Kunsthalle — *Joash shooting the arrow of deliverance*
The meeting of Jacob and Rachel
Landscape of Snowdonia

Great Britain

Aberdeen, Art Gallery — *Bacchus nursed by the nymphs of Nysa* (unfinished)
Westburn
Lowry William Frederick Dyce, the artist's nephew (*Goody Two-Shoes*)
Ann Webster
Alexander Webster
Mrs William Crombie
Isabella Dyce
The Highland ferryman
Sketch for John Knox dispensing the sacrament in Calder House
Titian preparing to make his first essay in colour
Charity (*Motherhood*)
The descent of Venus
Christ's entry into Jerusalem (unfinished)
Dante and Beatrice (unfinished)
Beatrice
Study for St John leading the Blessed Virgin Mary from the tomb

	A scene in Arran
Bedford, Cecil Higgins Art Gallery	*St John leading home his adopted mother*
Birmingham, City Art Gallery	*Christ and the woman of Samaria*
	Frances Maxwell and her son James
Brighton, Art Gallery	*Cain* (unfinished)
Edinburgh, John Knox's House	*John Knox dispensing the sacrament at Calder House*
Edinburgh, National Gallery of Scotland	*The infant Hercules strangling the serpents sent by Juno to destroy him*
	Francesca da Rimini
	St Catherine
	Shirrapburn Loch
	The Judgement of Solomon
	Religion: the vision of Sir Galahad and his company
Edinburgh, Scottish National Portrait Gallery	*Lady Cockburn*
	James Hamilton, MD
	Lady Meadowbank
Glasgow, Art Gallery	*Cristabel*
Leicester, City Art Gallery	*The meeting of Jacob and Rachel*
Liverpool, Sudley Art Gallery	*The Garden of Gethsemene*
London, Guildhall Art Gallery	*George Herbert at Bemerton*
	Henry VI at Towton
London, National Portrait Gallery	*General Sir Galbraith Lowry Cole*
London, Royal Academy of Arts	*Omnia vanitas (The penitent Magdalene)*
London, Tate Gallery	*Madonna and Child*
	St John leading the Blessed Virgin from the tomb
	Pegwell Bay – a recollection of October 5th. 1858
Nottingham, Castle Museum	*Madonna and Child*
Osborne House, Isle of Wight	*Neptune resigning to Britannia the empire of the sea*
	Virgin and Child
Southampton, Art Gallery	*The Hon. Charlotte Noel*

USA

Minneapolis, Institute of Art	*Eliazer of Damascus*

CHARLES LOCK EASTLAKE b. Plymouth 1793–d. Pisa 1865

Eastlake studied with Samuel Prout before training under Haydon and at the RA schools, and came to public notice in 1815 with his painting of the captive Napoleon, in a scene he had witnessed at Plymouth. After travel in Greece he settled in Rome for 14 years, painting scenes of Italian life and views of Rome while gaining a deep scholarly knowledge of Italian art. Returning to London in 1830, he became increasingly involved in art scholarship and administration. He later painted popular biblical scenes in an academic Italianate

manner but much of his time was occupied with official appointments; president of the Royal Academy in 1850 and director of the National Gallery from 1855. Eastlake exerted an important influence on taste by his purchase of early Italian paintings for the National Gallery and his involvement in the planning of the Palace of Westminster decorations.

Great Britain

Bedford, Cecil Higgins Art Gallery	*Moses and the daughters of Jethro*
Birkenhead, Williamson Art Gallery	*Brutus exhorting the Romans to avenge the death of Lucretia*
Birmingham, City Art Gallery	*The champion*
Chatsworth (Duke of Devonshire)	*The Spartan Isadas*
Exeter, Royal Albert Memorial Museum	*Cypresses at L'Arricia*
	Contemplation
Gateshead, Shipley Art Gallery	*Ruth and Boaz*
Glasgow, Art Gallery	*Christ lamenting over Jerusalem*
London, National Maritime Museum	*Napoleon aboard the Bellerophon in Plymouth Harbour Sound*
London, Royal Academy of Arts	*Hagar and Ishmael*
London, Sir John Soane's Museum	*Una delivering the Red Cross Knight from the cave of despair*
London, Tate Gallery	*Christ lamenting over Jerusalem*
	Escape of the Carrara family from the pursuit of the Duke of Milan
	Lord Byron's dream
	Haidee, a Greek girl
	Mrs Charles Bellenden Kerr as an Italian peasant girl
	The Colosseum from the Esqualine
	The Colosseum from the Campo Vaccino
London, Victoria and Albert Museum	*Peasant woman fainting from the bite of a serpent*
	Italian contadina and her children
	The Trajan Forum, Rome
Manchester, City Art Gallery	*Christ blessing little children*
Osborne House, Isle of Wight	*The Good Samaritan*
	The sisters
Woburn Abbey (Duke of Bedford)	*Pilgrims arriving in sight of Rome*

Greece
Athens, Benaki Museum	*Greek fugitives*

South Africa
East London, Ann Bryant Art Gallery	*The Colosseum, Rome*

USA
New Haven, Yale Center for British Art	*Temple of Erechtheus at Athens*

Poughkeepsie, Vassar College Art Gallery	*Greek brigands*
Providence, Rhode Island School of Design	*The Caelian Hills from the Palatine*

AUGUSTUS LEOPOLD EGG b. London 1816–d. Algiers 1863

Egg studied at Sass's Academy and at the RA schools, where as a member of a group calling themselves 'the Clique' he was friendly with Dadd and Frith (qq.v.). In the earlier part of his career he painted colourful scenes from history and literature in a manner popularized by Leslie (q.v.); though later he admired and encouraged the Pre-Raphaelites, and his modern-life subjects suggest that he was influenced by them. Possessed of sufficient private means to make him independent of painting for a living, Egg often lived in France and Italy because of ill health. He became ARA in 1849, RA in 1861, and also performed as an actor in Charles Dickens' amateur theatricals.

Canada
Ottawa, National Gallery of Canada	*Young Love*

Great Britain
Arbroath, Hospitalfield Trust	*Self-portrait as a poor student, 1858*
Birmingham, City Art Gallery	*Travelling companions*
Brighouse, Art Gallery	*Queen Elizabeth in a rage*
Harrogate, Art Gallery	*William Powell Frith*
Leicester, City Art Gallery	*Launce's substitute for Proteus' dog*
Liverpool, Walker Art Gallery	*Study for the Night before Naseby*
	Sir Piercie Shafton and Mysie Happer
	The knighting of Esmond
London, Guildhall Art Gallery	*Autolycus from 'A Winter's Tale'*
London, National Portrait Gallery	*Florence Nightingale*
London, Royal Academy of Arts	*Cromwell before Naseby*
London, Tate Gallery	*Beatrix knighting Esmond*
	Scene from 'Le diable boiteux'
	Past and Present (3 paintings)
Manchester, City Art Gallery	*A walk on the beach*
Oxford, Ashmolean Museum	*Outward bound*
	Desdemona
Preston, Harris Art Gallery	*Girl making a bouquet*
	The opera mantle
Sheffield, City Art Galleries	*Le diable boiteux*
	Lady in a green dress

USA
New Haven, Yale Center for British Art	*The life of Buckingham*
	The death of Buckingham

THOMAS FAED b. Burley Mill, Kirkcudbrightshire 1826–d. London 1900

One of three artist brothers, Faed studied in Edinburgh before settling in London in 1852. Trained within the stylistic tradition of Wilkie, Faed specialized in Scottish scenes, concentrating on the simple domestic sentiment of incidents from Burns or themes of homely peasant cottage life. The popular appeal of his subjects, frequently exhibited at the RA, led to many of Faed's works being engraved. He became a full academician in 1864, but resigned from the Academy in 1893 because of failing sight.

Australia

Adelaide, Art Gallery of South Australia	*Lucy's flitting*
Geelong, Art Gallery	*Reading the Bible*
Melbourne, National Gallery of Victoria	*The mitherless bairn*

Canada

Fredericton, Beaverbrook Art Gallery	*The tired street sweeper*
Montreal, Museum of Fine Arts	*Sunday in the backwoods*

Germany, West (FDR)

Hamburg, Hamburger Kunsthalle	*The sunbeam*
	The Flower of Dunblane

Great Britain

Aberdeen, Art Gallery	*Highland Mary*
	A seaside toilet
	The reaper
Accrington, Haworth Art Gallery	*Sunday afternoon in the backwoods*
Blackburn, Art Gallery	*The silken gown*
Blackpool, Grundy Art Gallery	*Molly's toilet*
Brighouse, Art Gallery	*The mitherless bairn* (version)
	Woman at a cottage door
Brighton, Art Gallery	*The mitherless bairn* (version)
Bristol, City Art Gallery	*Cottage interior with two children*
Broughty Ferry, Orchar Art Gallery	*The cut foot*
Bury, Art Gallery	*A listener ne'er hears guid o' himself*
	Jessie, the Flower of Dunblane
Edinburgh, Scottish National Portrait Gallery	*Scott and his friends*
Egham, Royal Holloway College	*Taking rest*
Exeter, Royal Albert Memorial Museum	*Hush!*
Glasgow, Art Gallery	*Violets and primroses*
	Where's my good little girl?
	Burns and Highland Mary
Kirkcaldy, Art Gallery	*A Lowland lassie*
Leicester, City Art Gallery	*Pot luck*
	The orphans

Liverpool, Sudley Art Gallery	*Free from care*
Liverpool, Walker Art Gallery	*When the children are asleep*
	In time of war
	The proposal
London, Guildhall Art Gallery	*Too young to be married*
	Forgiven
London, Royal Academy of Arts	*'Ere care begins*
London, Tate Gallery	*The silken gown*
	Faults on both sides
	Highland mother
London, Victoria and Albert	*The poor, the poor man's friend*
Museum	
Manchester, City Art Gallery	*Evangeline*
Newcastle, Laing Art Gallery	*The orange seller*
Oxford, Ashmolean Museum	*A peasant family*
Sheffield, City Art Galleries	*Auld Robin Grey*
	Robert Burns and Highland Mary
Southport, Atkinson Art Gallery	*The pet lamb*
Sunderland, Art Gallery	*Oh why left I my hame*
	And with the burden of many years
Wolverhampton, Art Gallery	*Sunday in the backwoods*
	The silken gown

South Africa

Durban, Art Gallery	*They had been boys together*

SAMUEL LUKE FILDES b. Liverpool 1844–d. London 1927

After study at Warrington School of Art, Fildes attended the South Kensington Schools. Before exhibiting at the RA from 1868, Fildes made designs for the *Graphic* and other magazines which Millais (q.v.) brought to the attention of Dickens who commissioned Fildes to illustrate *Edwin Drood*. The *Graphic*, a periodical highlighting social observation, was an important influence on Fildes, who became famous between 1870 and 1890 for a series of large social realist paintings showing emotive documentary scenes. Fildes, who visited Italy in 1875, also painted Venetian fancy pictures, though his greatest financial success was achieved in portraiture including a number of Royal commissions such as his repeated state portraits of Edward VII and George V.

Australia

Sydney, Art Gallery of New South	*The widower*
Wales	

Germany, West (FDR)

Hamburg, Hamburger Kunsthalle	*Venetian flower girl*

Great Britain

Aberdeen, Art Gallery	*Self-portrait*

Bournemouth, Russell-Cotes Art Gallery	*A fair study – Mrs Luke Fildes*
Cardiff, City Hall	*The return of the penitent*
Egham, Royal Holloway College	*Applicants for admission to a casual ward*
Liverpool, Sudley Art Gallery	*A Venetian flower girl*
Liverpool, Walker Art Gallery	*Mrs Luke Fildes*
	The widower (version)
London, Royal Academy of Arts	*A schoolgirl*
London, Tate Gallery	*Applicants for admission to a casual ward* (version)
	The doctor
Manchester, City Art Gallery	*Venetians*
	A devotee
	Carina
Port Sunlight, Lady Lever Art Gallery	*An al fresco toilet*
	W. H. Lever, later Lord Leverhulme
	Mrs W. H. Lever, later Lady Leverhulme
Preston, Harris Art Gallery	*Adoration*

STANHOPE ALEXANDER FORBES b. Dublin 1857–d. Newlyn 1947

After training at Lambeth School of Art and the RA schools, Forbes went to Paris in 1880 where he joined the studio of Bonnat. First visiting Brittany in 1881 with H.H. La Thangue, Forbes returned several times to the Breton coastal villages where he painted out-of-doors in the realist style of Bastien-Lepage. Forbes declared his dedication 'I must do *plein air* or nothing', and in 1884 he settled in Newlyn, Cornwall, where he gathered around him a group of like-minded artists. Forbes was the central member of this artistic community, and in 1899 with his artist wife Elizabeth he founded the Newlyn School of Art. He was a founder member of the New English Art Club and was elected RA in 1910.

Australia

Geelong, Art Gallery	*The pier head*
Sydney, Art Gallery of New South Wales	*Their ever-shifting home*

Great Britain

Aberdeen, Art Gallery	*Self-portrait*
Bath, Victoria Art Gallery	*Dr C. F. Watts*
Birmingham, City Art Gallery	*The village philharmonic*
Blackpool, Grundy Art Gallery	*Fading leaf and falling tree*
Bradford, Cartwright Hall	*Fitting out: Mousehole Harbour*
	The old pier steps
Brighton, Art Gallery	*Christmas Eve*
Bristol, City Art Gallery	*Home-along evening*
Cardiff, National Museum of Wales	*The little smithy*
Exeter, Royal Albert Memorial Museum	*22nd January 1901 (Reading the news of the Queen's death in a Cornish cottage)*

Hartlepool, Gray Art Gallery	*A gala day at Newlyn*
	Evening, the workers return
Hull, Ferens Art Gallery	*At their moorings*
	Newlyn
Ipswich, Christchurch Mansion	*Forging the anchor*
Liverpool, Walker Art Gallery	*A street in Brittany*
	Off to the fishing grounds
London, Imperial War Museum	*WRNS ratings sail-making*
London, Royal Academy of Arts	*The harbour window*
London, Tate Gallery	*The health of the bride*
Manchester, City Art Gallery	*The lighthouse, Newlyn*
Newcastle, Laing Art Gallery	*Round the camp fire*
Newport, Art Gallery	*Still waters*
	The pond
Oldham, Art Gallery	*The drinking place*
Plymouth, City Art Gallery	*A fish sale on a Cornish beach*
	The letter
	The village rendezvous: Copperhouse Creek near Hayle
Preston, Harris Art Gallery	*Fishing boats at low tide against the New Quay, Newlyn*
	On the bridge

New Zealand

Auckland, City Art Gallery	*A Cornish fisherman*
Dunedin, Public Art Gallery	*Preparations for the market, Quimperlé*

South Africa

Durban, Art Gallery	*A New Song*

WILLIAM POWELL FRITH b. Aldfield, near Ripon 1819–d. London 1909

Frith trained at Sass's Academy and at the RA schools where during the 1840s along with Dadd, Egg (qq.v.) and others he was a member of 'The Clique', a group of ambitious young artists who reacted against the conservatism of the RA. Frith painted some portraits, but primarily achieved his sound commercial success by selecting popular subjects from literature or history which allowed him to specialize in anecdotal costume pieces. From his student days Frith expressed a desire to paint pictures of modern life, but felt discouraged by the attitude of critics and by what he considered to be the ugliness of contemporary dress. In 1854, however, following the success of the Pre-Raphaelites, Frith exhibited *Ramsgate Sands* (Royal Collection) which was the first of his enormously popular crowded panoramic views of modern life. His autobiography gives a clear account of the busy professional life of a successful Victorian artist.

Australia

Melbourne, National Gallery of Victoria	*Measuring heights*

| Perth, Art Gallery of Western Australia | *The match seller* |

Canada

Fredericton, Beaverbrook Art Gallery	*The new model*
Ottawa, National Gallery of Canada	*Sketch for The Salon d'Or, Bad Homburg*
Vancouver, Art Gallery	*Sketch for Coming of age in the olden times*

Great Britain and Northern Ireland

Aberdeen, Art Gallery	*Self-portrait 1876*
	Incident in the life of Lady Mary Wortley Montagu
	The highwayman
Arbroath, Hospitalfield Trust	*Self-portrait with a flower girl, 1875*
Belfast, Ulster Museum	*Sterne at Montreuil*
Birmingham, City Art Gallery	*Garden flowers*
Bournemouth, Russell-Cotes Art Gallery	*Life at the seaside* (*Ramsgate Sands*) (version)
Brighouse, Art Gallery	*The duke's blessing*
	The rivals
Cambridge, Fitzwilliam Museum	*Othello and Desdemona*
Cardiff, National Museum of Wales	*Tenby prawnseller*
Derby, Art Gallery	*The artist's model*
Egham, Royal Holloway College	*The railway station* (*Paddington station*)
Exeter, Royal Albert Memorial Museum	*The fair toxopholites*, or *English archers 19th century*
Glasgow, Art Gallery	*Princess Alexandrina Victoria*
Harrogate, Art Gallery	*A dream of the past* (version)
	Many happy returns of the day
Leicester, City Art Gallery	*The railway station* (small version)
	The miniature
Liverpool, Sudley Art Gallery	*Sketch for The village pastor*
Liverpool, Walker Art Gallery	*Prayer*
	The duel scene
	Marriage of the Prince of Wales and Princess Alexandra, 1863 (version)
London, Guildhall Art Gallery	*The Saracen's head*
London, National Portrait Gallery	*Self-portrait 1838*
	Self-portrait with a model
	Mrs Mary Elizabeth Maxwell
London, Royal Academy of Arts	*The sleeping model*
London, Tate Gallery	*Derby Day*
	Dolly Varden
	Uncle Toby and the Widow Wadman
London, Victoria and Albert Museum	*Charles Dickens*
	Dolly Varden
	Lucy Ashton and Ravenswood
	Sketch for Derby Day

	Scene from 'A Sentimental Journey'
	Scene from 'Le Bourgeois Gentilhomme'
	Measuring heights (version)
	Mr Honeywood introduces the bailiffs to Miss Richards as his friends
	The village merrymaking
	Sancho Panza tells a tale to the Duke and Duchess
Manchester, City Art Gallery	*The squire teaching the children to box*
	Derby Day (version)
	Claude Duval
	Scene from 'Le Bourgeois Gentilhomme'
Nottingham, Castle Museum	*The invalid*
Oxford, Ashmolean Museum	*Before dinner at Boswell's lodgings*
Preston, Harris Art Gallery	*At the opera*
	Nora Creina
	Scene from 'Le Bourgeois Gentilhomme'
Sheffield, City Art Galleries	*The Bride of Lammermoor*
	The toilet
	John Knox reproving Mary Queen of Scots
South Shields, Art Gallery	*The knight and the maid*
Wolverhampton, Art Gallery	*The rejected poet*

New Zealand

Auckland, City Art Gallery	*The proposal*
	Pope makes love to Lady Mary Wortley Montagu
Dunedin, Public Art Gallery	*Study for Life at the seaside (Ramsgate Sands)*

South Africa

Durban, Art Gallery	*The procession of Our Lady of Boulogne*
Johannesburg, Art Gallery	*The artist's model*
	The pulse, the husband

USA

Providence, Rhode Island School of Design	*The Salon d'Or, Bad Homburg*

JOHN ATKINSON GRIMSHAW b. Leeds 1836–d. Knostrop Hall, Leeds 1893

Grimshaw received his art education in Leeds when he was influenced by the ideas of Ruskin concerning the precise and detailed rendering of nature. He painted interior scenes usually showing a solitary woman in her domestic surroundings; he also developed the theme of the townscape as a subject for painting, often choosing scenes of docks or city streets by moonlight or gaslight. His 'nocturnes' were admired by Whistler (q.v.).

Great Britain

Blackpool, Grundy Art Gallery	*View of Liverpool*
Bournemouth, Russell-Cotes Art Gallery	*An autumn idyll*
Bradford, Cartwright Hall	*Fiamella*
	Ingleborough from under White Scar, Yorkshire limestone strata
Brighouse, Art Gallery	*A mossy glen*
	Pall-Mall, London
Gateshead, Shipley Art Gallery	*November morning, Knostrop Hall, Leeds*
	Greenwich, half tide
Gloucester, Art Gallery	*Gloucester Docks*
Harrogate, Art Gallery	*A Yorkshire home*
Huddersfield, Art Gallery	*The full orbed Queen of Night*
	Liverpool Docks
	The sun's farewell
	Silver moonlight
Hull, Ferens Art Gallery	*Princes Dock, Hull*
Leeds, City Art Gallery	*Autumn glory: the old mill*
	The Seal of the Covenant
	Tree shadows on the park wall, Roundhay
	In peril (The harbour flare)
	Leeds bridge
	Nightfall down the Thames
	Iris
	Scarborough at dusk
	Reflections on the Thames, Westminster
London, Guildhall Art Gallery	*The Thames by moonlight with Southwark Bridge*
London, Tate Gallery	*Heath Street, Hampstead, by night*
	Liverpool Quay by moonlight
Newcastle, Laing Art Gallery	*Under the beech trees*
Preston, Harris Art Gallery	*The Rector's garden: Queen of the Lilies*
	In the golden olden times
	Golden visions
Scarborough, Art Gallery	*Burning off*
	Lights in the harbour
Sheffield, City Art Galleries	*Night scene*
Wakefield, City Art Gallery	*Baiting the lines, Whitby*

JOHN ROGERS HERBERT b. Maldon 1810–d. Kilburn, London 1890

After training at the RA schools between 1826 and 1828, Herbert visited Italy where he was impressed with the work of the German Nazarene painters. In addition to portraits and landscapes, after his conversion to Roman Catholic-ism in 1840 he produced Biblical subjects in an Italianate manner which are similar to the paintings of Dyce (q.v.); and his *Our Saviour subject to his Parents at Nazareth* (1847) can be seen as a precursor of Millais' *Christ in the House of*

his Parents. Herbert contributed to the Palace of Westminster frescoes and was elected RA in 1841.

Australia

| Melbourne, National Gallery of Victoria | *Moses bringing down the Tablets of the Law* |

Germany, West (FDR)

Hamburg, Hamburger Kunsthalle	*Moses with the Tablets of the Law (The descent from Sinai)*
	An Egyptian maid
	The sower of good seed
	Gibraltar coast scene
	Nile landscape
	Siut, Egypt

Great Britain

Birkenhead, Williamson Art Gallery	*The brides of Venice*
Bury, Art Gallery	*The crusader's wife*
Liverpool, Sudley Art Gallery	*Woodland scene*
Liverpool, Walker Art Gallery	*Judith and Holofernes*
London, Guildhall Art Gallery	*Our Saviour subject to His parents at Nazareth (The childhood of Our Lord)*
London, Royal Academy of Arts	*St Gregory teaching his chant*
London, Tate Gallery	*Laborare est orare*
	Sir Thomas More and his daughter
Penrhyn Castle (National Trust)	*The Baptist reproving Herod*
Preston, Harris Art Gallery	*Cordelia disinherited*
	The Boy Daniel condemning the false elder
Sunderland, Art Gallery	*Landscape with mountains, lake and figures*
Wolverhampton, Art Gallery	*Francesca*

FRANCIS (FRANK) BERNARD HOLL b. London 1845–d. London 1888

Holl, the son and pupil of the engraver Francis Holl, was a student at the RA schools from 1860, and following the success of *The Lord gave and the Lord hath taken away* (1868) he was awarded a travelling scholarship to Italy in 1869. Like Fildes (q.v.), Holl was a contributor to the *Graphic*; in the earlier part of his career he concentrated on subjects of emotive social realism, and from 1877 frequently painted portraits. His painting of 1870 *No tidings from the sea* (Royal Collection) was bought by Queen Victoria and he was elected RA in 1882.

Australia

Melbourne, National Gallery of Victoria	*Widowed*
	The daughter of the house
	Home again (Home from the front)

Great Britain

Aberdeen, Art Gallery	*Self-portrait*
Birmingham, City Art Gallery	*John Bright*
	Edmund Tonks
Bristol, City Art Gallery	*James Harvey*
	Miss Rachel Harvey
Dundee, City Art Gallery	*Her first-born – Horsham Churchyard*
Egham, Royal Holloway College	*Newgate, committed for trial*
Exeter, Royal Albert Memorial Museum	*The song of the shirt*
Leeds, City Art Gallery	*'I am the Resurrection and the Life' (The village funeral)*
Liverpool, Walker Art Gallery	*A fisherman's home*
London, Guildhall Art Gallery	*The Lord gave and the Lord hath taken away, blessed be the name of the Lord*
London, National Portrait Gallery	*Self-portrait*
London, Royal Academy of Arts	*Sir John Everett Millais*
London, Tate Gallery	*Hush!*
	Hushed
	The artist's mother
London, Victoria and Albert Museum	*Edgar Holl as a boy*
	Head of a Welsh fishergirl
Southampton, Art Gallery	*Hope*
	Despair

ARTHUR HUGHES b. London 1832–d. Kew 1915

Trained under Alfred Stevens and at the Royal Academy, Hughes was influenced by the ideas of the Pre-Raphaelites after reading their magazine, *The Germ,* and meeting members of the group. Though never a member of the Brotherhood, Hughes worked with them on the Oxford Union frescoes in 1858 and his earlier work shares their glowing colours and the exquisite detailed rendering of fabrics and natural forms. In later years Hughes produced many books illustrations and the subject matter of his painting became less narrative and more lyrical in mood.

Australia

Melbourne, National Gallery of Victoria	*Fair Rosamond*
	La Belle Dame sans Merci

Canada

Toronto, Art Gallery of Ontario	*Lady with the lilacs*

Great Britain

Aberdeen, Art Gallery	*The mower*
Beverley, Art Gallery	*Springtime in Cornwall*
Birmingham, City Art Gallery	*The long engagement*
	The Nativity
	The Annunciation

	Musidora
	Amy
	The lost child
	The young poet
Bournemouth, Russell-Cotes Art Gallery	*Home from work*
Bristol, City Art Gallery	*The guarded bower*
Cambridge, Fitzwilliam Museum	*The king's orchard*
	Edward Robert Hughes as a child
Carlisle, Art Gallery	*The rift in the lute*
	Madelaine
Lincoln, Usher Art Gallery	*Rest*
Liverpool, Walker Art Gallery	*Sir Galahad – the quest of the Holy Grail*
	'As You Like It' triptych, 'Blow, Blow thou Winter Wind'
London, National Portrait Gallery	*Self-portrait*
London, Tate Gallery	*The Eve of St Agnes triptych*
	April love
	The tryst – Aurora Leigh's dismissal of Romney
	The woodman's child
	There was a Piedmontese....
London, Victoria and Albert Museum	*The white hind*
Manchester, City Art Gallery	*Ophelia*
Newcastle, Laing Art Gallery	*The potter's courtship*
Oxford, Ashmolean Museum	*Study for The Eve of St Agnes triptych*
	Home from the sea (The sailor boy or The mother's grave)
	Cecily Palgrave
	Ophelia
	Girl in a violet dress
Port Sunlight, Lady Lever Art Gallery	*A music party*
Preston, Harris Art Gallery	*Bed-time*
Sheffield, City Art Galleries	*In the grass*
Walthamstow, William Morris Gallery	*The first Easter: 'He is risen'*

USA

Toledo, Toledo Museum of Art	*Ophelia: 'And he will not come back again'*

WILLIAM HOLMAN HUNT b. London 1827–d. London 1910

After copying in the National Gallery and British Museum, Hunt in 1844 entered the RA schools where he became a close friend of Millais (q.v.). In 1848–49, inspired by Ruskin's *Modern Painters*, which emphasized truth to

nature and praised the paintings of the early Italians, Hunt joined with
Millais, Rossetti (qq.v.) and others to form the Pre-Raphaelite Brotherhood
(PRB). Alone amongst the members of the PRB, Hunt was undeviating in his
adherence to the founding principles of the movement; these included detailed
realism and fidelity to nature, high moral purpose and originality in subject
matter, and a demanding technique which involved painting on a wet white
ground and working out of doors. As well as painting literary subjects and
didactic moralities of modern life, Hunt visited the Holy Land in 1854, 1869
and 1873 to establish exact archaeological and topographical background for
his biblical pictures which were enormously popular as engravings. Hunt
painted very slowly, with an unwavering sense of moral purpose, and created
an art in which symbolic meaning is presented in an intensely realistic guise.

Australia
Melbourne, National Gallery of Victoria — *The importunate neighbour*

Canada
Ottawa, National Gallery of Canada — *Henry Wentworth Monk*

Great Britain
Aberdeen, Art Gallery — *Past and present*
Birmingham, City Art Gallery — *Self-portrait, 1845*
Dante Gabriel Rossetti
Valentine rescuing Sylvia from Proteus
The finding of Christ in the Temple
May Morning on Magdalen Tower, Oxford
Street scene in Cairo, the lantern-maker's courtship
Cambridge, Fitzwilliam Museum — *The Thames at Chelsea, evening*
Cyril Benoni Holman Hunt
Coventry, Herbert Art Gallery — *Stratford-upon-Avon*
Leeds, City Art Gallery — *Study for The shadow of death*
Leicester, City Art Gallery — *Christ among the doctors*
Liverpool, Sudley Art Gallery — *The finding of the Saviour in the Temple*
Liverpool, Walker Art Gallery — *The triumph of the innocents*
Sketch for The eve of St Agnes
London, Guildhall Art Gallery — *The flight of Madeleine and Porphyro*
London, National Portrait Gallery — *Stephen Lushington*
London, St Paul's Cathedral — *The Light of the World* (version)
London, Tate Gallery — *The haunted manor*
The ship
The triumph of the innocents
F. G. Stephens
Claudio and Isabella
The awakening conscience
Our English coasts (*Strayed sheep*)
Manchester, City Art Gallery — *The scapegoat* (version)
The hireling shepherd

	The shadow of death (version)
	Sketch for The Light of the World
	The Lady of Shalott (version)
	The lantern-maker's courtship (version)
Newcastle, Laing Art Gallery	*Isabella and the pot of basil*
Oxford, Ashmolean Museum	*The festival of St Swithin's (The dovecote)*
	The schoolgirl (Mirian Wilkinson)
	Self-portrait aged 14
	A converted British family sheltering a Christian missionary from the persecution of the Druids
	The afterglow in Egypt (version)
	The Plains of Esdraelon from the heights above Jerusalem
	London Bridge at night, the celebration of the marriage of the Prince of Wales, 1863
Oxford, Keble College Chapel	*The Light of the World*
Port Sunlight, Lady Lever Art Gallery	*The scapegoat* (version)
	May Morning on Magdalen Tower, Oxford (version)
Preston, Harris Art Gallery	*The back of the Sphinx, Gizeh*
Sheffield, City Art Galleries	*Little Nell and her grandfather*
Southampton, Art Gallery	*The afterglow in Egypt* (version)

Puerto Rico

| Ponce, Museo de Arte | *The school of nature* |

South Africa

| Johannesburg, Art Gallery | *Sunset in the Val d'Arno* |

USA

Cambridge, Fogg Art Museum	*The miracle of the sacred fire*
Hartford, Wadsworth Atheneum	*The Lady of Shalott* (version)
Wilmington, Delaware Art Museum	*Isabella and the pot of basil* (version)

EDWIN HENRY LANDSEER b. London 1802–d. London 1873

Landseer was a precocious artist who began exhibiting at the RA at the age of 12, establishing a public reputation in 1818 when he sold *Fighting dogs getting wind* to Sir George Beaumont. His early work shows the influence of Snyders and Rubens. Encouraged by Haydon, his depiction of animals was based on anatomical dissection. Landseer, famous for his large and heroic Highland canvases begun after visiting Scotland in 1824, in his smaller works humanized domestic animals, endowing them with sentimental pathos and unfortunate charm. He painted his first portrait of Queen Victoria in 1839 and became a frequent visitor at Osborne and Balmoral. In addition to the popularity evinced through the numerous engravings made of his works, Landseer received public honours and acclaim throughout his career, although increasing

melancholia led to his refusing the Presidency of the RA in 1865. He sculpted
the four bronze lions in Trafalgar Square, London, which were unveiled in
1867. Several of his important works are in the Royal Collection and his
renowned *Monarch of the Glen* and *Stag at Bay* are both in private collections.
War and *Peace* were destroyed in the Tate flood, 1928.

Australia

Adelaide, Art Gallery of South Australia	*Wild ducks in flight*
Melbourne, National Gallery of Victoria	*Titania and Bottom*
	The earl and countess of Sefton with their daughter

Germany, West (FDR)

Hamburg, Hamburger Kunsthalle	*The poacher's bothie*

Great Britain

Aberdeen, Art Gallery	*Flood in the Highlands*
Anglesey Abbey (National Trust)	*Scottish landscape*
	Head of a goat
	Queen Victoria's favourite dog, Dash
Barnsley, Cooper Art Gallery	*Horses, dogs and figures*
	Deerhounds
Birmingham, City Art Gallery	*The hunting of Chevy Chase*
Bournemouth, Russell-Cotes Art Gallery	*A Highland flood*
Burnley, Towneley Hall Art Gallery	*Eos – a greyhound*
Bury, Art Gallery	*A random shot*
Buscot Park (National Trust)	*Study for Death of a stag at Glen Tilt*
Coventry, Herbert Art Gallery	*Lady Godiva's prayer*
Edinburgh, National Gallery of Scotland	*Rent day in the wilderness*
Egham, Royal Holloway College	*Man proposes, God disposes*
Liverpool, Sudley Art Gallery	*Dog with a slipper*
	Lake scene
	Taking the deer: the Duke of Athol with foresters
	A hunting scene
Liverpool, Walker Art Gallery	*Study for War*
	Study of rocks and rivulet
London, Apsley House	*The illicit whisky still*
London, Guildhall Art Gallery	*The first leap – Lord Alexander on Emerald*
London, Kenwood	*Hawking in olden times*
	The Hon. E. S. Russell and his brother on ponies
London, National Portrait Gallery	*Sir Walter Scott*
	2nd Viscount Melbourne
	John Allen
London, Royal Academy of Arts	*The faithful hound*

London, Tate Gallery	*Sleeping bloodhound*
	The Duchess of Abercorn and child
	Loch Avon and the Cairngorms
	A distinguished member of the Humane Society
	The hunted stag
	Low life
	High life
	King Charles spaniels (The cavalier's pets)
	Scene at Abbotsford
	The defeat of Comus
	John Landseer, the artist's father
	Shoeing
	Dialogue at Waterloo
	Alexander and Diogenes
	Dignity and Impudence
	Boy, donkey and foal, mischief in full play
	Highland music
London, Victoria and Albert Museum	*Suspense*
	There's no place like home
	The old shepherd's chief mourner
	The dog and his shadow
	A frog
	The twa' dogs
	A fireside party
	The angler's guard
	A jack in office
	Young roebuck and rough hounds
	The eagle's nest
	Tethered rams watched by two dogs
	The drover's departure – scene in the Grampians
	A Highland breakfast
	The stonebreaker and his daughter
	A naughty child
	Sancho Panza and Dapple
London, Wallace Collection	*Looking for crumbs from the rich man's table (Doubtful crumbs)*
	A Highland scene
	The Arab tent
Manchester, City Art Gallery	*On the Tilt, Perthshire*
	Bolton Abbey, Yorkshire
Newcastle, Laing Art Gallery	*Wild cattle at Chillingham*
	Deer, Chillingham Park, Northumberland
Nottingham, Castle Museum	*Deer in a landscape*
Oxford, Ashmolean Museum	*Studies of a stag's head*
	Queen Victoria on a highland pony

Port Sunlight, Lady Lever Art
 Gallery

Bird study – a ruff
Low life (version)

Preston, Harris Art Gallery
Sheffield, City Art Galleries

Puppy teasing a frog
A stray shot
The battle of Chevy Chase
Count d'Orsay's charger
The young laird

Sunderland, Art Gallery
Wolverhampton, Art Gallery

Bolton Abbey in the olden days
Queen Victoria in Windsor Home Park
The Duchess of Bedford, Duke of Gordon
 and Lord Alexander Russell (Deer-
 stalking in the Highlands)

Ireland, Republic of
Dublin, National Gallery of Ireland

The Sheridan family

South Africa
Johannesburg, Art Gallery

The lion and the lamb

USA
Detroit, Institute of Arts

Weel, sir, if the deer got the ball sure's
 death Chevy will no leave him

Hartford, Wadsworth Atheneum
Louisville, J. B. Speed Museum
New Haven, Yale Center for British
 Art

The otter hunt (version)
The Sutherland children
Van Amburgh and the lions

FREDERIC LEIGHTON b. Scarborough 1830–d. London 1896

Leighton's family travelled extensively during his youth and he gained his
general education and artistic training in Rome, Florence and Frankfurt,
where he studied with Steinle, a follower of the German 'Nazarene' group.
While he was still abroad, Leighton's first Royal Academy exhibit, *Cimabue's
celebrated Madonna carried in procession through the streets of Florence* (1855), was
bought by Queen Victoria; he thus early received royal patronage in what
was to prove a long and successful career, which culminated in 1896 when as
president of the RA Leighton was elevated to the peerage. When he settled in
London in 1860 Leighton turned from biblical and medieval subjects to
mythological and Hellenic themes, developing from his foreign experience a
cosmopolitan academicism of style. Versions of his scultures *The sluggard* and
Athelete struggling with a python are owned by the Royal Academy and the Tate
Gallery.

Australia
Adelaide, Art Gallery of South
 Australia

The feigned death of Juliet

Sydney, Art Gallery of New South
 Wales

Winding the skein
Wedded

Study for The arts of Industry applied to Peace

Canada

Ottawa, National Gallery of Canada *Sansone*
 Actaea, the nymph of the shore
Vancouver, Art Gallery *Tolla*

Germany, West (FDR)

Frankfurt, Stadelsches Kunstinstitut *Self-portrait*
 Johann G. F. Schierholz
Hamburg, Hamburger Kunsthalle *Biondina*

Great Britain

Aberdeen, Art Gallery *Self-portrait*
Accrington, Haworth Art Gallery *Faith*
Anglesey Abbey (National Trust) *Bend in a river*
Barnsley, Cooper Art Gallery *Street in Lerici*
Bath, Victoria Art Gallery *Alexandra Leighton*
Bedford, Cecil Higgins Art Gallery *Courtyard of a mosque at Broussa*
Birmingham, City Art Gallery *Garden of an inn, Capri*
 A condottiere
 Study for And the sea gave up the dead
 which were in it
Blackburn, Art Gallery *Mother and child with cherries*
Bournemouth, Russell-Cotes Art *Study for Perseus and Andromeda*
 Gallery
Brighouse, Art Gallery *Faust and Marguerite*
Bristol, City Art Gallery *The fisherman and the syren*
Buscot Part (National Trust) *Daedalus and Icarus*
Cambridge, Fitzwilliam Museum *Miss Laing*
 Clytie
Compton, Watts Gallery *Head of an Italian girl*
Greenock, Art Gallery *Yasmeenah*
Hull, Ferens Art Gallery *Electra at the tomb of Agamemnon*
 Farewell!
Kilmarnock, Dick Institute *Greek girls playing at ball*
Leeds, City Art Gallery *The return of Persephone*
Leicester, City Art Gallery *Perseus on Pegasus hastening to the rescue*
 of Andromeda
Liverpool, Sudley Art Gallery *Weaving the wreath*
 A sunny corner
 Study – at a reading desk
Liverpool, Walker Art Gallery *An Italian crossbowman*
 Elijah in the wilderness
 An elegy
 Perseus and Andromeda
London, Guildhall Art Gallery *Music lesson*
London, Leighton House *A boy saving a baby from the clutches of*
 an eagle

	The Hon. Frederick Wellesley as a child
	Music
	Dance
	The death of Brunelleschi
	A Persian peddler
	Dr Frederic Septimus Leighton
	Orpheus and Eurydice
	A noble lady of Venice
	Clytemnestra on the battlements of Argos watching for the return of Agamemnon
	Elisha raising the Shunammite's son
	Corinna of Tanagra
	A selection of landscape studies and preliminary sketches
London, National Portrait Gallery	*Richard Burton*
London, Royal Academy of Arts	*St Jerome*
London, Tate Gallery	*Sketch for Count Paris*
	The bath of Psyche
	'And the sea gave up the dead which were in it'
London, Victoria and Albert Museum	*The arts of Industry applied to War* (sketch, cartoon and fresco)
	The arts of Industry applied to Peace (sketch, cartoon and fresco)
Manchester, City Art Gallery	*Isle of Chios*
	The Temple of Phylae
	The last watch of Hero
	Leander drowned
	Captive Andromache
Oxford, Ashmolean Museum	*Acme and Septimus*
	Preparing for a fiesta, Florence
Port Sunlight, Lady Lever Art Gallery	*The Daphnephoria*
	Psamathe
	The garden of the Hesperides
	Faticida
	Sketch for Clytie
Preston, Harris Art Gallery	*Interior of the Grand Mosque of Damascus*
Scarborough, Art Gallery	*Jezebel and Ahab go down to take possession of Naboth's vineyard*
Wallington Hall (National Trust)	*Woody landscape*
Walthamstow, William Morris Gallery	*Head of a girl (Dorothy Dene)*

New Zealand

Auckland, City Art Gallery	*Melittion*
	The Spirit of the Summit
	Teresina
Christchurch, McDougal Art Gallery	

Puerto Rico
Ponce, Museo de Arte *Flaming June*

USA
Boston, Museum of Fine Arts *Stella*
Fort Worth, Kimbell Art Museum *Miss May Sartoris*
Milwaukee, Art Center *At the fountain*
Minneapolis, Institute of Art *Jonathan's token to David*
New Haven, Yale Center for British *Mrs James Guthrie*
 Art
New York, Metropolitan Museum of *Lucia*
 Art *Lachrymae*
Princeton, University Art Museum *After Vespers*
Washington, Maryhill Museum of *Solitude*
 Fine Arts

CHARLES ROBERT LESLIE b. London 1794–d. London 1859

Born in England of American parents, Leslie spent his youth in Philadelphia,
returning to London in 1811 and entering the RA schools in 1813. Although
encouraged by Benjamin West, Leslie soon turned away from the grandiose
traditions of history painting and established his success with small anecdotal
genre pictures, particularly of subjects from literature. Elected RA in 1826,
and a professor at the Academy in 1857, Leslie published significant books of
artistic instruction and memoirs and, in 1843, a standard biography of John
Constable with whom he was a close friend.

Great Britain and Northern Ireland
Belfast, Ulster Museum *Don Quixote*
 Sancho Panza
Blackpool, Grundy Art Gallery *At the pool*
Brighouse, Art Gallery *Scene from The Pirate*
Liverpool, Walker Art Gallery *Hermione*
London, Apsley House *The Duke of Wellington looking at a bust*
 of Napoleon
London, National Portrait Gallery *Self-portrait, 1814*
 John Everett Millais
London, Royal Academy of Arts *Katherine of Aragon with her maid*
 John Constable
London, Tate Gallery *Sancho Panza in the apartment of the*
 Duchess
 Uncle Toby and the Widow Wadman
 Scene from Milton's 'Comus'
 Lady Jane Grey prevailed on to accept the
 crown
 Sketch for the Duke and Duchess reading
 'Don Quixote'
 Sketch for Christ rebuking his disciples by
 calling the little child

	Three studies of Falstaff
	Sketch for Slender courting Anne Page
	Sketch for Charles II and Lady Bellenden
	Viola and Olivia
	Sketch for 'Rape of the Lock'
	Sketch for 'Twelfth Night'
London, Victoria and Albert Museum	*Scene from 'The Taming of the Shrew'*
	The principal characters in 'The Merry Wives of Windsor'
	Who can this be?
	Who can this be from?
	Uncle Toby and Widow Wadman
	Florizel and Perdita
	Autolycus
	Le Bourgeois Gentilhomme
	'Les Femmes Savantes' – Trissotin reading his sonnet
	Le Malade Imaginaire
	Laura introduces Gil Blas to Arsenia
	Sketch of Don Quixote and Dorothea
	Queen Katherine and Patience
	The two Princes in the Tower
	Amy Robsart, Countess of Leicester
	The toilette
	Portia
	Griselda
	Queen Victoria in her coronation robes
	A garden scene – the artist's youngest son with his toys
	Sancho Panza
Petworth (National Trust)	*Gulliver presented to the queen of Brobdignag*
	Sancho and the duchess
	Lucy Percy, Countess of Carlisle, bringing the pardon to her father
Preston, Harris Art Gallery	*Perdita*
	The present
	Olivia raising her veil
	Sir John Falstaff
	Consultation
Sheffield, City Art Galleries	*Scene from 'The Merry Wives of Windsor'*
Stratford, Royal Shakespeare Theatre Picture Gallery	*Mrs Charles Kean as Hermione*
	Scene from 'The Merry Wives of Windsor'
Wolverhampton, Art Gallery	*The Duchess of Sutherland in coronation robes*

USA

Boston, Museum of Fine Arts	*John Howard Payne*
Chicago, Art Institute of Chicago	*James William Wallack*

New York, Metropolitan Museum of Art	*Dr John Wakefield Francis*
Philadelphia, Atheneum	*Timon of Athens*
Philadelphia, Pennsylvania Academy of Fine Arts	*The murder of Rutland by Lord Clifford*

JOHN FREDERICK LEWIS b. London 1805–d. Walton-on-Thames 1876

Lewis studied as a youth with Landseer (q.v.) and his early paintings are of animals. From 1825 he specialized in watercolour, and during the next 15 years exhibited scenes from travels in Italy and Spain at the Water-Colour Society (RWS) of which he became president in 1855. After living in Rome for two years, Lewis settled in Cairo in 1841 where he stayed for ten years absorbing the repertoire of Middle Eastern themes for which he is particularly known. When he began to exhibit again in London in 1850, his precise craftsmanship and jewelled colours attracted the acclaim of Ruskin. Resigning from the RWS in 1858, Lewis returned to oil painting and was elected RA in 1865. He often repeated compositions in both oil and watercolour.

Australia

Melbourne, National Gallery of Victoria	*An eastern interior – study for The harem*

Canada

Ottawa, National Gallery of Canada	*Viscount Castlereagh's attendants*

Great Britain

Bedford, Cecil Higgins Art Gallery	*Entrance to the harem*
	The Bazaar, Cairo
Birkenhead, Williamson Art Gallery	*Interior of a school, Cairo*
Birmingham, City Art Gallery	*The pipe bearer*
	Lilium auratum
	The harem
	The doubtful coin
	Mule and muleteer
	Tomb of St Catherine, Mt Sinai
	Study for The doubtful coin
Broughty Ferry, Orchar Art Gallery	*Part of the Propylon at Philae*
Cambridge, Fitzwilliam Museum	*A Syrian schiek*
	Caged doves, Cairo
	The siesta
	Courtyard of the Alhambra
	Wounded roebuck
	Falls on the Rhine, Neuhausen
London, Royal Academy of Arts	*The doorway of a café, Cairo*
London, Tate Gallery	*Buck-shooting in Windsor Great Park*
	Sketch for Buck-shooting in Windsor Great Park
	Edfu, Upper Egypt

46 LEWIS

London, Victoria and Albert Museum	*Study for Courtyard of the Coptic Patriarch's house, Cairo* *The siesta* *Study of a fox* *Study of a dead lapwing* *Head of a steinbock* *Peasants in the Black Forest* *Mehemet ali Pasha* *The hareem* *Life in the harem, Cairo* *A halt in the desert* *A slave market in the East* *Interior of a school, Cairo*
Manchester, City Art Gallery	*The coffee bearer* *Newhaven fisherwoman*
Manchester, Whitworth Art Gallery	*A Spanish fiesta* *Indoor gossip, Cairo, a scene in the harem*
Newcastle, Laing Art Gallery	*The lioness* *Harem life, Constantinople*
Newport, Art Gallery	*Altenahr*
Northampton, Art Gallery	*Easter Day at Rome*
Oxford, Ashmolean Museum	*Entrance to the Baths of the Alhambra* *Study for The proclamation of Don Carlos*
Preston, Harris Art Gallery	*In the Bey's garden, Asia Minor*
Sheffield, City Art Galleries	*Egyptian interior*
Sunderland, Art Gallery	*Easter Day at Rome*

New Zealand

| Auckland, City Art Gallery | *Young woman with a rose* |
| Dunedin, Public Art Gallery | *The bouquet* |

South Africa

| Johannesburg, Art Gallery | *A Berber interior*
A Persian nobleman |

USA

| New Haven, Yale Center for British Art | *'And the prayer of faith shall heal the sick'*
The reception
On the banks of the Nile, Upper Egypt
The houri (Eastern lady with a hookah)
Study of a lioness
A Turkish araba
Grey mare and chestnut foal in a farmyard
Ferreting
Roman pilgrims
A Frank encampment in the desert of Mount Sinai |
| San Marino, Huntington Art Gallery | *A Bazaar scene* |

EDWIN LONG b. Bath 1829–d. Hampstead 1891

Long was a pupil of John Phillip, an artist who specialized in Spanish subjects and in 1857, following the first of three visits to Spain, Long began his career by exhibiting paintings of incidents in Spanish life. In addition to portraits, and influenced by Poynter and Alma-Tadema (qq.v.), Long later painted biblical and Egyptian themes: large crowded canvases containing much antiquarian research which had wide popular appeal and gained him enormous financial success. Long was elected RA in 1881 and the following year his *Babylonian marriage market* sold for over 6000 guineas, a saleroom record for the work of a living British painter.

Australia

Geelong, Art Gallery	*The Babylonian maid*
Melbourne, National Gallery of Victoria	*Queen Esther*
	A question of propriety
Sydney, National Gallery of New South Wales	*A Dorcas meeting in the 6th C.*

Great Britain

Aberdeen, Art Gallery	*A Spanish girl praying*
Bath, Victoria Art Gallery	*The raising of Jairus' daughter*
	The cousins
Blackburn, Art Gallery	*Diana or Christ?*
Bournemouth, Russell-Cotes Art Gallery	*Alethe, a priestess of Isis*
	'Then to her listening ear'
	Pensive
	The martyr
	Jephthah's vow
	The chosen five
	Anno domini or the Flight into Egypt
	In the wilderness
	The suppliants
	The moorish proselytes of Archbishop Ximines, Granada
	A street scene in Spain
Bradford, Cartwright Hall	*An Egyptian feast*
Bristol, City Art Gallery	*Pharoah's daughter – the finding of Moses*
	Ruth the gleaner
Burnley, Towneley Hall Art Gallery	*The gods and their makers*
Egham, Royal Holloway College	*The Babylonian marriage market*
	The suppliants: expulsion of the gipsies from Spain
Exeter, Royal Albert Memorial Museum	*Samuel Cousins*
London, National Portrait Gallery	*Lord Randolph Churchill*
London, Royal Academy of Arts	*Nouzhatoul-Aoudat – 'The delight of the home'*
London, Victoria and Albert Museum	*Velasquez*

Oldham, Art Gallery *Spanish beggars*
Sheffield, City Art Galleries *Princess Helen Randir Singh*
Wolverhampton, Art Gallery *At prayer*
 Peter's Pence

DANIEL MACLISE b. Cork 1806–d. Chelsea 1870

Maclise studied at the Cork Academy before entering the RA schools in 1828
where he gained medals for both drawing and painting. At first he worked as
a portraitist, including caricature portraits published 1830–36 in *Fraser's
Magazine*, and he later extended his range of subjects to include literary genre,
fairy painting, allegory and historical themes. His larger history paintings are
ambitious multiple figure compositions displaying emphatic draughtsman-
ship, complex poses and strong colouring. Influenced by German painters
and illustrators, Maclise's tendency towards the monumental was encouraged
by his commission for two frescoes in the Palace of Westminster, *The Spirit of
Chivalry* and *The Spirit of Justice* and culminated in the epic achievement of
his later years (1857–65), his two frescoes in the Royal Gallery of Westminster
Palace, each over 45 feet long, *The meeting of Wellington and Blucher* and *The
death of Nelson*.

Germany, West (FDR)
Hamburg, Hamburger Kunsthalle *Babes in the wood*

Great Britain
Bury, Art Gallery *The student*
Cardiff, National Museum of Wales *John Orlando Parry*
Carlisle, Art Gallery *First steps*
Egham, Royal Holloway College *Peter the Great at Deptford Dockyard*
Hartlepool, Gray Art Gallery *The sleeping beauty*
Knebworth House, Hertfordshire *Edward IV visiting Caxton's printing
 press at Westminster*
 Edward Bulwar-Lytton
Leeds, City Art Gallery *Noah's sacrifice*
Leicester, City Art Gallery *The rat catcher – a sketch*
Liverpool, Walker Art Gallery *Sketch for William Harrison Ainsworth*
 The death of Nelson
 Madelaine at prayer
London, Guildhall Art Gallery *The trial of William Wallace*
 The banquet scene from 'Macbeth'
London, National Portrait Gallery *Charles Dickens*
 William Harrison Ainsworth
London, Royal Academy of Arts *The woodranger*
 The meeting of Wellington and Blucher
 (cartoon)
London, Tate Gallery *The play scene from 'Hamlet'*
 Malvolio and the Countess
 Charles Dickens

London, Victoria and Albert Museum	*Girl at the waterfall at St Nectan's near Tintagel*
	John Forster
	Scene from Jonson's 'Every Man in his Humour'
	Macready as Werner
Manchester, City Art Gallery	*A winter night's tale*
	The origin of the harp
Newcastle, Laing Art Gallery	*King Alfred in the camp of the Danes*
Preston, Harris Art Gallery	*Rosalind and Celia watching the wrestlers*
Sheffield, City Art Galleries	*The Spirit of Chivalry* (cartoon)
	Yes or no
Stratford, Royal Shakespeare Theatre Picture Gallery	*Miss Priscilla Horton as Ariel*
	The Play scene from 'Hamlet'
Wolverhampton, Art Gallery	*The pet bird*
	The denial

Ireland, Republic of

Cork, Municipal Art Gallery	*The falconer*
Dublin, National Gallery of Ireland	*Charles I and his children before Oliver Cromwell*
	Merry Christmas in the baron's hall
	Gil Blas dressed as a cavalier
	The marriage of Strongbow and Eva
	Edmund Kean as Hamlet

New Zealand

| Auckland, City Art Gallery | *The Spirit of Justice* |

South Africa

| Cape Town, South African National Gallery | *The witches from 'Macbeth'* |
| Johannesburg, Art Gallery | *Othello and Desdemona* |

USA

| Toledo, Toledo Museum of Art | *The standard bearer, a life study* |

JOHN MARTIN b. Haydon Bridge 1789–d. Douglas, Isle of Man 1854

Briefly apprenticed to an heraldic painter, Martin had his major early training with an Italian artist working in Britain, Bonifazio Musso. In 1806 he went to London where he worked as an enamel painter on china and glass and began to exhibit at the RA from 1811. Throughout his life Martin was interested in engineering, and spent years devising schemes to improve London's water supply. After 1816, following the exhibition of *Joshua commanding the sun to stand still*, he became famous for a series of large oils on themes of cataclysmic disaster where vast and precisely scaled architectural perspectives dominated minuscule figures against a background of livid skies. Martin's art combines the ideals of 'sublime' landscape derived from Turner's historical landscapes with elements of the spectacular showmanship associated with de

Loutherbourg's *Eidophusikon*. Martin's popular reputation was spread by mezzotints of his works and his engraved illustrations to Milton and the Bible.

Great Britain

Anglesey Abbey (National Trust)	*The repentance of Nineveh*
Birmingham, City Art Gallery	*The Celestial City and Rivers of Bliss*
	Pandemonium
Cambridge, Fitzwilliam Museum	*Twilight in the woodlands*
Edinburgh, National Gallery of Scotland	*Macbeth and Banquo on the blasted heath*
Glasgow, Art Gallery	*Adam's first sight of Eve*
	Distant view of London
Kirkcaldy, Art Gallery	*The Garden of Eden*
Liverpool, Walker Art Gallery	*The Last Man*
London, Tate Gallery	*The fallen angels entering Pandemonium*
	The Great Day of His Wrath
	The Last Judgement
	The plains of Heaven
	The coronation of Queen Victoria
London, Victoria and Albert Museum	*Adam listening to the voice of the Almighty*
Newcastle, Laing Art Gallery	*The Bard*
	Marcus Curtius
	Haydon Bridge
	The Last Man
	Clytie
	Edwin and Angelina – The Hermit
	Solitude
	The expulsion of Adam and Eve from Paradise
	The Entrance to Carisbrook Castle
	Arthur and Aegle in the Happy Valley
	The destruction of Sodom and Gomorrah
	Belshazzar's feast (loan)
	Joshua commanding the sun to stand still (loan)
Southampton, Art Gallery	*Sadak in search of the waters of oblivion*
York, City Art Gallery	*Christ stilleth the tempest*

USA

Boston, Museum of Fine Arts	*The seventh plague of Egypt*
New Haven, Yale Center for British Art	*The Bard* (version)
	The Crucifixion
	Belshazzar's feast (version)
Toledo, Museum of Art	*The destruction of Tyre*

ROBERT BRAITHWAITE MARTINEAU b. London 1826–d. London 1869

After studying law, Martineau in 1851 entered the RA schools where he became a friend and pupil of Holman Hunt (q.v.); they continued to share a studio until Martineau's marriage in 1865. Working slowly in the meticulous Pre-Raphaelite technique, Martineau produced only a few finished oils during his brief career. His best known work *The last day in the old home* (1861) is reputed to have taken him over ten years to complete, and is a prime example of the adage 'Every picture tells a story'.

Great Britain

Birmingham, City Art Gallery	*The last chapter*
Liverpool, Walker Art Gallery	*Christians and Christians* (unfinished)
	Conway Castle
London, Tate Gallery	*Kit's writing lesson*
	The last day in the old home
	Picciola (The prison flower)
Manchester, City Art Gallery	*The artist's wife in a red cape*
Oxford, Ashmolean Museum	*The knight's guerdon*
	The artist's wife
	Katherine and Petruchio
	The poor actress's Christmas dinner (unfinished)
	Alice Holdsworth with a hoop (unfinished)

South Africa

Johannesburg, Art Gallery	*Girl with a cat*

JOHN EVERETT MILLAIS b. Southampton 1829–d. London 1896

Millais entered the RA schools at the unprecedented age of 11, exhibiting from 1846, and he was to end his successful and highly professional career as president of the Royal Academy and as the first British artist to be made a baronet. His competent academic art training and technical mastery always set Millais apart from Hunt, Rossetti (qq.v.) and the other artists with whom he founded the Pre-Raphaelite Brotherhood in 1848, although he continued to produce carefully observed and tightly executed works in a Pre-Raphaelite manner until 1857. After his marriage to the former wife of John Ruskin in 1855, his work became freer in handling and more sentimental in subject matter. Amongst his late works are many society portraits and popular fancy pictures of children, such as the famous *Bubbles* which is in a private collection.

Australia

Melbourne, National Gallery of Victoria	*The rescue*
	Diana Vernon
Sydney, National Gallery of New South Wales	*The captive*

Canada
Ottawa, National Gallery of Canada *The Marquess of Lorne*

Germany, West (FDR)
Hamburg, Hamburger Kunsthalle *The minuet*

Great Britain
Aberdeen, Art Gallery *Self-portrait*
 The convalescent (Getting better)
 Bright eyes
Birmingham, City Art Gallery *The Blind Girl*
 Waiting
 A widow's mite
 The parable of the tares
 My second sermon (version)
Blackpool, Grundy Art Gallery *The letter box*
Brighouse, Art Gallery *Reflection*
Bristol, City Art Gallery *The Bride of Lammermoor*
Buscot Park (National Trust) *The enemy sowing tares*
Cambridge, Fitzwilliam Museum *Mrs Coventry Patmore*
 The bridesmaid (All Hallow's Eve)
Cardiff, National Museum of Wales *Jephthah's daughter*
Dundee, City Art Gallery *Puss in boots*
Edinburgh, National Gallery of *'Sweetest eyes were ever seen'*
 Scotland *The proscribed loyalist* (loan)
Egham, Royal Holloway College *The Princes in the Tower*
 Princess Elizabeth
Glasgow, Art Gallery *The Forerunner*
 The ruling passion (The Ornithologist)
Kilmarnock, Dick Institute *Day dreams*
Leeds, City Art Gallery *Infancy*
 Youth
 Manhood
 Old age
 Poetry
 Music
Liverpool, Sudley Art Gallery *Vanessa*
 Sketch for Ferdinand lured by Ariel
 Landscape, Hampstead
Liverpool, Walker Art Gallery *Lorenzo and Isabella*
 Rosalind in the forest
 The Martyr of the Solway
 The good resolve
London, Guildhall Art Gallery *The woodman's daughter*
 My first sermon
 My second sermon
London, Leighton House *Robert Rankin*
London, National Portrait Gallery *Thomas Carlyle*
 Wilkie Collins

	William Gladstone
	Lord Beaconsfield
	Arthur Sullivan
London, Royal Academy of Arts	*A souvenir of Velasquez*
London, Tate Gallery	*Ophelia*
	Christ in the house of His parents (The Carpenter's Shop)
	The order of release, 1746
	The vale of rest
	Mrs Bischoffsheim
	The boyhood of Raleigh
	The North-west passage – it might be done and England ought to do it
	Speak! Speak!
	The yeoman of the guard
	The knight errant
	The moon is up
	Mercy, St. Bartholomew's Day, 1572
	St Stephen
	Hearts are trumps
	Charles I and his son in the studio of Van Dyck
	Maid offering a basket of fruit to a cavalier
London, Victoria and Albert Museum	*Pizarro seizing the Inca of Peru*
	The Eve of St Agnes
Manchester, City Art Gallery	*Only a lock of hair*
	Glen Birnam
	Victory O Lord!
	A flood
	Stella
	Wandering thoughts
	Death of Romeo and Juliet
	Autumn leaves
	Winter fuel
Oldham, Art Gallery	*Thomas Oldham Barlow*
Oxford, Ashmolean Museum	*The return of the dove to the ark*
	Thomas Combe
Perth, Art Gallery	*Waking (Just awake)*
	Effie Grey
	Chill October (loan)
Port Sunlight, Lady Lever Art Gallery	*A dream of the past: Sir Isumbras at the ford*
	The Black Brunswicker
	Idyll of 1745
	Lingering Autumn
	Alfred, Lord Tennyson
	The little Speedwell's darling blue
St Helier, Jersey, Fort Regent	*A Jersey Lily (Lily Langtry)*

Sheffield, City Art Galleries	*The proposal*
Southampton, Art Gallery	*On the banks of the Dee*
Stratford, Royal Shakespeare	*Lord Ronald Sutherland Gower*
Theatre Picture Gallery	*Scene from 'Hamlet'*
Wightwick Manor (National Trust)	*The Foxglove: Effie Ruskin*

Ireland, Republic of

Dublin, National Gallery of Ireland	*Lilacs*

New Zealand

Auckland, City Art Gallery	*Grace*
	'Blow blow thou winter wind'

Puerto Rico

Ponce, Museo de Arte	*The escape of a heretic*

South Africa

Johannesburg, Art	*The fringe of the moor*
Gallery	*Stitch! Stitch!*
	Cuckoo!

USA

Baltimore, Walters Art Gallery	*News from home*
Cambridge, Fogg Art Museum	*The proscribed royalist*
Malibu, Getty Museum	*The ransom*
Minneapolis, Institute of Art	*Peace concluded*
New Haven, Yale University Art	*Yes or no* (lent to Yale Center)
Gallery	
New York, Metropolitan Museum of	*Portia*
Art	
Wilmington, Delaware Art Museum	*A Highland lassie*
	The waterfall
	The white cockade
	Master Mavor

ALBERT JOSEPH MOORE b. York 1841–d. Kensington 1893

A younger brother in an artistic family, Moore was exhibiting at the RA by the age of 15, but stayed only briefly at the RA schools, later travelling and working in France and Rome. His early Old Testament paintings were Pre-Raphaelite in style, but after his return to England in 1863 his increasing interest in colour and design was reflected in decorative murals for houses by the architects William Nesfield and Norman Shaw. Moore's later paintings, based upon numerous nude and draped preliminary studies, are exclusively of posed, frieze-like figures in classical drapery, often of similar or repeated compositions enabling him to examine various colour relationships. Moore was a close friend of Whistler (q.v.), supporting him at the libel trial against Ruskin; like Whistler he substituted a symbol for his signature, and gave his paintings deliberately oblique titles that have only an incidental reference to their subject matter.

Great Britain

Bedford, Cecil Higgins Art Gallery	*Oranges*
Birkenhead, Williamson Art Gallery	*Sea gulls*
	A memory
Birmingham, City Art Gallery	*Dreamers*
	Sapphires
	Birds (Canaries)
Blackburn, Art Gallery	*The Loves of the Winds and the Seasons*
Bournemouth, Russell-Cotes Art Gallery	*Midsummer*
Bury, Art Gallery	*Elijah's sacrifice*
Cambridge, Fitzwilliam Museum	*The umpire*
Carlisle, Art Gallery	*The mother of Sisera looked out*
Compton, Watts Gallery	*Jasmine*
Edinburgh, National Gallery of Scotland	*Beads*
Glasgow, Art Gallery	*Reading aloud*
Liverpool, Walker Art Gallery	*A summer night*
	Sea shells
	The Shulamite relating the glories of King Solomon to her maidens
London, Fulham Public Library	*Apricots*
London, Guildhall Art Gallery	*Pomegranates*
London, Tate Gallery	*Blossoms*
	The toilet
	The garden
London, Victoria and Albert Museum	*St Patrick*
	Sketch for 'Somnus'
Manchester, City Art Gallery	*A reader*
	An idyll
	A footpath
	Birds of the air
	A garland
Oxford, Ashmolean Museum	*Study of an ash trunk*
Sheffield, City Art Galleries	*Sketch for 'Battledore'*
	Sketch for 'Shuttlecock'
York, City Art Gallery	*A Venus*
	Kingcups
	End of a sofa (Sketch for Apples)
	The wardrobe door

Ireland, Republic of

Dublin, Municipal Gallery of Modern Art	*Azaleas*

South Africa

Johannesburg, Art Gallery	*A wardrobe (Venus)*

USA

New Haven, Yale Center for British Art	*The musician*
Williamstown, Clark Art Institute	*Lilies*
Wilmington, Delaware Art Museum	*The green butterfly*

WILLIAM QUILLER ORCHARDSON b. Edinburgh 1832–d. London 1910

In 1845 Orchardson entered the Trustees Academy, Edinburgh, where from 1852 he was influenced by the teaching of Robert Scott Lauder. From 1862 Orchardson settled in London, sharing a studio with Pettie (q.v.), his fellow student from Edinburgh. Their continued friendship is reflected in their similar compositional approach where empty space is used with telling impact, and both share a technique of thinly applied paint and an enthusiasm for Jacobean and Regency costume pieces. In addition to scenes from history and literature, particularly from Shakespeare, Orchardson was an important portraitist and is well known for his development of pictures of upper-class psychological drama such as *Mariage de convenance*.

Australia

Melbourne, National Gallery of Victoria	*The first cloud*

Canada

Fredericton, Beaverbrook Art Gallery	*The duke's antechamber*

Great Britain and Northern Ireland

Aberdeen, Art Gallery	*The broken tryst*
	Self-portrait
	Toilers of the sea
	A social eddy – left by the tide
	Mariage de convenance – after
	Lady Robertson
	The doves (*Feeding pigeons*)
	The Borgia
Belfast, Ulster Museum	*Emma Joseph*
Birmingham, Barber Institute of Fine Arts	*Lady Orchardson, the artist's wife*
Bournemouth, Russell-Cotes Art Gallery	*Study for Windsor Castle 1899: the four generations*
Broughty Ferry, Orchar Art Gallery	*The lyric*
	Study for Her first dance
	A revolutionist
	Winding her skein
	Self-portrait
	The feather boa (*Lady in a brougham*)
	Study for The social eddy
	The connoisseur – afternoon sketch

Dundee, Art Gallery	*Study for 'Voltaire'*
Edinburgh, National Gallery of Scotland	*Study for 'Queen of the swords'*
	Voltaire
	Master Baby
	The rivals
	Lady Orchardson, the artist's wife
Edinburgh, Scottish National Portrait Gallery	*Thomas Alexander Graham*
Glasgow, Art Gallery	*Mariage de convenance*
	The farmer's daughter
	Casus belli
	The young housewife
	James Tullis
	Mrs Tullis
Greenock, Art Gallery	*Testing the blade*
Kirkcaldy, Art Gallery	*Enigma*
Liverpool, Walker Art Gallery	*The chinese cabinet*
	16th Earl of Derby
London, National Maritime Museum	*Napoleon on board the Bellerophon* (loan from Tate)
London, National Portrait Gallery	*Four generations: Queen Victoria, Edward VII, George V, Duke of Windsor*
London, Royal Academy of Arts	*On the North Foreland*
London, Tate Gallery	*Her first dance*
	The first cloud
	Her mother's voice
Manchester, City Art Gallery	*Her idol*
	Mrs John Pettie
Nottingham, Castle Museum	*Self-portrait*
Port Sunlight, Lady Lever Art Gallery	*The young duke*
	St Helena 1816 – Napoleon dictating to Las Cases the account of his campaigns
Sheffield, City Art Galleries	*Little Nell and her grandfather*
Southampton, Art Gallery	*The Flowers of the Forest*
Wolverhampton, Art Gallery	*The story of a life*

Ireland, Republic of

Dublin, Municipal Gallery of Modern Art	*Imogen in the Cave of Belarius*

South Africa

Cape Town, South African National Gallery	*The challenge*
Johannesburg, Art Gallery	*Morning gossip*

SAMUEL PALMER b. London 1805–d. London 1881

After training with William Wate, a topographical artist, Palmer began to exhibit at the RA from 1819, but the important artistic influence on his work

came from his meeting with the painter John Linnell who introduced him to William Blake in 1824. This experience, particularly the inspiration of Blake's illustrations to Virgil's *Eclogues*, combined with his intense religious faith and encouraged him to develop his visionary landscapes. Between 1825 and 1834 Palmer worked in Shoreham, Kent, producing intense pastoral visions replete with Christian symbolism. After his marriage to Linnell's daughter in 1837 his landscapes became more conventional, although late in life he recaptured his youthful spiritual ecstasy in illustrations to Milton.

Australia

Adelaide, Art Gallery of South Australia — *Summer storm near Pulborough* / *Harvest picnic*

Melbourne, National Gallery of Victoria — *Culbone, Somerset* / *Golden city; Rome from the Janiculum* / *Carting the wheat*

Canada

Ottawa, National Gallery of Canada — *Oak trees, Shoreham, Kent*

Great Britain

Aberdeen, Art Gallery — *Harvesting*

Birmingham, City Art Gallery — *Sheep crossing a stream* / *Ancient Rome* / *Modern Rome* / *Tityrus restored to his patrimony*

Cambridge, Fitzwilliam Museum — *The magic apple tree*

Carlisle, Art Gallery — *Harvest moon, Shoreham*

Chatsworth (Duke of Devonshire) — *The bellman* / *Morning*

Leeds, City Art Gallery — *Moonrise* / *Double rainbow*

London, Tate Gallery — *The bright cloud* / *A hilly scene* / *Coming from evening Church* / *A dream in the Apennines* / *The Waterfalls, Pistyll Mawddach* / *The gleaning field (Harvest moon)*

London, Victoria and Albert Museum — *Hasting to cover, threatening rainstorm* / *Cartshed and lane* / *Country road leading to a church* / *Villa d'Este, Tivoli* / *Tintern Abbey* / *In a Shoreham garden* / *Farmyard near Princes Risborough* / *Ruth returning from gleaning* / *The water's murmuring (Il Penseroso)* / *The eastern gate (L'Allegro)* / Other watercolours and drawings

Manchester, Whitworth Art Gallery — *The sleeping shepherd* / *Viaggiatori*

Newcastle, Laing Art Gallery	*Pastoral*
Oxford, Ashmolean Museum	*Pastoral with horsechestnut tree*
	Old house on the banks of the Darenth, Shoreham
	The valley thick with corn
	Early morning with rabbit
	Rustic scene
	Late twilight
	The skirts of a wood
	Valley with a bright cloud
	The flock and the star
	Shepherds under a full moon
	Villa d'Este, Tivoli
	Self-portrait
	Rest on the flight
	Young man yoking an ox
	Other watercolours and drawings
Preston, Harris Art Gallery	*The dawn of life*

USA

New Haven, Yale Center for British Art	*Pistyll Mawddach, North Wales*
	Moonlight with a winding river
	The valley of vision
	Cow lodge with a mossy roof
	The harvest moon
Philadelphia, Museum of Art	*View of Tivoli*
Toledo, Museum of Art	*Tivoli*
	Evening landscape

JOHN PETTIE b. Edinburgh 1839–d. Hastings 1893

Pettie entered the Trustees Academy, Edinburgh, in 1855 where he established his life-long association with Orchardson (q.v.) and together with others, such as Graham and MacTaggart, these pupils of R. S. Lauder evolved a distinct 'Scottish' school of painting in which they made use of a theatrical sense of open space and painted with a light loose brushwork quite unlike the tightly finished and crowded compositions of their English contemporaries. After settling in London in 1862, Pettie painted inventive and dramatic scenes suggested by history and literature. Noted for his use of light backgrounds, he later turned to portraiture, in which he continued to display his interest in costume, depicting his sitters in period dress.

Australia

Melbourne, National Gallery of Victoria	*Challenged*
	Arrest for witchcraft

Canada

Montreal, Museum of Fine Arts	*Touchstone and Audrey*

Germany, West (FDR)
Hamburg, Hamburger Kunsthalle *Edward VI signing his first death warrant*

Great Britain
Aberdeen, Art Gallery

Tustle for the keg
Sylvius and Phoebe
The sanctuary
Thomas Faed
Self-portrait
A musician's reverie
Scene in Hal o' the Wynd's smithy

Arbroath, Hospitalfield Trust *Hunted down*
Birkenhead, Williamson Art Gallery *Wedding procession with shepherd and flock*
Interior with four figures

Bristol, City Art Gallery *Sketch for Charles Surface selling his ancestors*
Hunted down

Broughty Ferry, Orchar Art Gallery *The world went very well then*
Scene from 'Peveril of the Peak'
To the fields he carried her milking pails
A Highland outpost
The laird
The young laird
Alice in Wonderland

Cambridge, Fitzwilliam Museum *Mrs Bossom, the artist's mother-in-law*
Dundee, City Art Gallery *The doctor's visit*
Disbanded
Sketch for Ho! Ho! Old Noll

Edinburgh, National Gallery of Scotland *Cromwell's Saints*
Who goes?

Edinburgh, Scottish National Portrait Gallery *Sir W. Q. Orchardson*

Egham, Royal Holloway College *A state secret*
Glasgow, Art Gallery *Two strings to her bow*
Sketch for A sword and dagger fight (The duel)
Ho! Ho! Old Noll
The strategists

Hull, Ferens Art Gallery *Terms to the besieged*
The sally

Leeds, City Art Gallery *Fixing the site of an early Christian altar*
The commencement of the quarrel

Liverpool, Walker Art Gallery *Scene in the Temple Gardens (The choosing of the red and white roses)*

London, Royal Academy of Art *Jacobites, 1745*
Thomas Faed

London, Tate Gallery *The vigil*
Self-portrait

Manchester, City Art Gallery	*The Duke of Monmouth pleading for his life before James II*
	A Song without words
Oxford, Ashmolean Museum	*The artist's wife*
Sheffield, City Art Galleries	*The drumhead court martial*
	The sword and the dagger fight (To the death)
	The disgrace of Cardinal Wolsey
	The flag of truce
	Hudibras and Ralpho in the stocks
	The puritan
	The royalist
Stratford, Royal Shakespeare Theatre Picture Gallery	*Juliet and Friar Lawrence*
Wolverhampton, Art Gallery	*An arrest for witchcraft*
	Cleared out

South Africa

Cape Town, South African National Gallery	*The Duke of Monmouth pleading for his life before James II*

EDWARD JOHN POYNTER b. Paris 1836–d. London 1919

Poynter met Leighton (q.v.) in Italy in 1853 and was inspired by his conception of a new academic neo-classical art; he returned to London to study at the RA schools, and later (1856–59) worked in the studio of Gleyre in Paris, where he became acquainted with Whistler (q.v.). After returning to London in 1860 Poynter's first success was with *Israel in Egypt* (1867), although he later turned to Greek and Roman subjects similar to the work of Alma-Tadema (q.v.). In a career full of public honours he was Slade professor from 1871, director of the National Gallery 1894–1906 and professor of the RA from 1896. His teaching and art was grounded in the academic tradition of figure drawing and he prepared nude studies for each figure in his compositions.

Australia

Adelaide, National Gallery of South Australia	*Helena and Hermia*
Hobart, Tasmanian Art Gallery	*Chloe*
Sydney, National Gallery of New South Wales	*The visit of the Queen of Sheba to King Solomon*
	Helen
	The Hon. Violet Monckton

Canada

Montreal, Museum of Fine Arts	*Cinderella*

Great Britain

Aberdeen, Art Gallery	*Self-portrait*
Bateman's (National Trust)	*Classical temple*
	Rudyard Kipling

	Views of Bateman's
Birmingham, City Art Gallery	*Bells of St Mark's, Venice*
Bournemouth, Russell-Cotes Art Gallery	*Cleopatra, a sketch*
Bristol, City Art Gallery	*The Vision of Endymion* (version)
	Horae serenae
Burnley, Towneley Hall Art Gallery	*On the temple steps*
Coventry, Herbert Art Gallery	*Young girl with monkey*
	Seated crippled man
Exeter, Royal Albert Memorial Museum	*Diadumene*
Liverpool, Walker Art Gallery	*Faithful unto death*
	Psyche in the Palace of Love
	Mercury stealing the cattle of the Gods
London, Guildhall Art Gallery	*Israel in Egypt*
London, Royal Academy of Art	*The fortune-teller*
London, Tate Gallery	*A visit to Aesculapius*
	Outward bound
	Paul and Apollos
London, Victoria and Albert Museum	*Apelles*
	Pheidias
Manchester, City Art Gallery	*The Ides of March*
	The vision of Endymion
Newcastle, Laing Art Gallery	*The catapult*
Newport, Art Gallery	*Offering to Isis*
Southampton, Art Gallery	*Study for Faithful unto death*
Wolverhampton, Art Gallery	*The champion swimmer*

New Zealand

| Wellington, National Gallery of New Zealand | *Asterie* |

USA

| Wilmington, Delaware Art Museum | *In a garden* |

RICHARD REDGRAVE-b. Pimlico 1804-d. London 1888

Redgrave entered the RA schools in 1826 and began his career painting landscapes and 18th-century historical genre. In the 1840s he pioneered subjects in contemporary dress containing commentary on social themes such as emigration and the position of women. Redgrave dedicated much of his life to official duties; he was Keeper of Paintings at the South Kensington Museum, followed Dyce (q.v.) as advisor on schemes for national art education and, with his brother Samuel, wrote an important history of British painting, *A Century of Art*. His later works are mostly landscapes and designs for pottery and glass.

Germany, West (FDR)

| Hamburg, Hamburger Kunsthalle | *The idler* |

Great Britain

Birmingham, City Art Gallery	*The valleys also stand thick with corn*
Brighouse, Art Gallery	*Cinderella*
Gateshead, Shipley Art Gallery	*The poor teacher*
London, National Portrait Gallery	*Self-portrait*
London, Royal Academy of Arts	*The outcast*
London, Tate Gallery	*Country cousins*
	The emigrant's Last Sight of home
London, Victoria and Albert Museum	*The governess*
	Ophelia weaving her garlands
	Cinderella about to try on the glass slipper
	Gulliver exhibited to the Brobdignag farmer
	Throwing off her weeds
	Sweet summer time – sheep in Wotton meadows near Dorking
	Bolton Abbey – morning
	An Old English homestead
	The Thames from Millbank
	The stream at rest
	Quentin Matsys in his studio
	Donatello
Wolverhampton, Art Gallery	*The children in the wood*

USA

New Haven, Yale Center for British Art	*Self-portrait*

DANTE GABRIEL CHARLES ROSSETTI b. London 1828– d. Birchington-on-Sea 1882

Born of Italian parents, Rossetti had a life-long obsession with his namesake, Dante. Impatient with the artistic training at the RA schools, he left to be apprenticed to F. M. Brown (q.v.) and became a founder member of the Pre-Raphaelite Brotherhood. He produced, however, only two paintings based on truly Pre-Raphaelite principles, his work of the 1850s and early 1860s being largely watercolours and drawings of subjects from Dante and from Malory's *Morte d'Arthur*, which almost always included his wife Elizabeth Siddal as model. After her death in 1862 he returned to oils, painting particularly femme-fatale figures whose strange facial type was modelled on Jane Morris, wife of William Morris. Rossetti as both poet and painter often based his works on his own writings, thus associating himself with Blake of whom he was an early admirer. His poetic vision is more akin to the work of the Symbolists of the 1890s for whom Rossetti was a major source of inspiration.

Canada

Ottawa, National Gallery of Canada	*The salutation of Beatrice* (diptych)

Germany, West (FDR)

Hamburg, Hamburger Kunsthalle	*Helen of Troy*

Great Britain

Aberdeen, Art Gallery	*Mariana*
Birmingham, Barber Institute of Fine Arts	*The blue bower*
Birmingham, City Art Gallery	*Beata Beatrix* (version)
	Proserpine (version)
	The boat of Love
	A large collection of drawings
Bournemouth, Russell-Cotes Art Gallery	*Venus verticordia*
Buscot Park (National Trust)	*Pandora*
	Venus verticordia
Cambridge, Fitzwilliam Museum	*Girl at a lattice*
	Joan of Arc
Cardiff, National Museum of Wales	*Fair Rosamund*
Carlisle, Art Gallery	*Studies for 'Found'*
Dundee, Art Gallery	*Dante's Dream at the time of the death of Beatrice* (version)
Edinburgh, National Gallery of Scotland	*Beata Beatrix* (version)
Glasgow, Art Gallery	*Regina cordium* (*Alice Wilding*)
Liverpool, Sudley Art Gallery	*The two mothers*
Liverpool, Walker Art Gallery	*Dante's dream at the time of the death of Beatrice*
Llandaff, Cathedral	*The Seed of David* (triptych)
London, Guildhall Art Gallery	*La Ghirlandata*
London, Tate Gallery	*Girlhood of the Virgin Mary*
	Ecce Ancilla Domini! (*The Annunciation*)
	St Catherine
	Fazio's mistress (*Aurelia*)
	Beata Beatrix
	Dantis amor
	Bethlehem gate
	Sancta lilias
	Proserpine (version)
	Mrs Vernon Lushington
	Monna Vanna (*Belcolore*)
	The Beloved (*The bride*)
London, Victoria and Albert Museum	*The day dream* (*Monna primavera*)
Manchester, City Art Gallery	*Joli coeur*
	The bower meadow
	Astarte Syriaca
Nottingham, Castle Museum	*Marigolds* (*Bower maiden* or *Fleurs de Marie* or *Gardener's daughter*)
Port Sunlight, Lady Lever Art Gallery	*Sibylla palmifera* (*Venus palmifera*)
	The Blessed Damozel (version)
Wightwick Manor (National Trust)	*Mrs William Morris*

Puerto Rico
Ponce, Museo de Arte *Roman widow (Dis manibus)*

South Africa
Johannesburg, Art Gallery *Regina cordium*

USA
Boston, Isabella Stewart Gardner Museum *Love's greeting*

Boston, Museum of Fine Arts *Before the battle*

Cambridge, Fogg Art Museum *My Lady Greensleeves*
Il Ramoscello (Bella e Buona)
The Blessed Damozel
A sea-spell
La Donna della finestra (The lady of pity)

Chicago, Art Institute of Chicago *Beata Beatrix* (version)

Toledo, Museum of Art *The salutation of Beatrice*

Wilmington, Delaware Art Museum *Found* (unfinished)
Lady Lilith
Water willow
Veronica Veronese
La Bella Mano
Mary Magdalena
Mnemosyne

CLARKSON STANFIELD b. Sunderland 1793–d. Hampstead 1867

After a brief apprenticeship to an heraldic painter in Edinburgh, Stanfield spent his early working life as a merchant seaman (1808–15); he then began his artistic career as a scene painter in London. He continued to work in the theatre throughout his life, producing both conventional stage sets and the fashionable and popular 'Dioramas' – moving panoramas of scenery involving dramatically changing light effects. Stanfield, who travelled extensively throughout his career, first exhibited RA 1820 and was elected RA 1835. He was a highly successful painter of seascapes, naval engagements and wreck subjects and was compared by his contemporaries to Turner. His most famous painting of a wreck, *The Abandoned*, remains untraced, but it is known through an engraving.

Australia
Melbourne, National Gallery of Victoria *St Michael's Mount, Cornwall*
The morning following the battle of Trafalgar

Germany, West (FDR)
Bonn, Rheinisches Landesmuseum *The Rhine at Cologne*
Burg Eltz

Hamburg, Hamburger Kunsthalle *St Michael's Mount, Cornwall*

Great Britain and Northern Ireland

Bath, Victoria Art Gallery	*Calais: fishermen taking in nets, squall coming on*
Belfast, Ulster Museum	*Stack Rock, Antrim*
Birkenhead, Williamson Art Gallery	*Coast of Normandy near Gronville*
Brighton, Art Gallery	*Entrance to Teignmouth Harbour*
Bury, Art Gallery	*On the River Texel*
Cambridge, Fitzwilliam Museum	*Coast scene near Genoa*
Egham, Royal Holloway College	*The battle of Roveredo*
	View of the Pic du Midi d'Ossau in the Pyrenees
Gateshead, Shipley Art Gallery	*The coming storm, Calais*
Hull, Ferens Art Gallery	*Alkmaar*
Leicester, City Art Gallery	*Macbeth and the witches*
Liverpool, Sudley Art Gallery	*Scene in the Gulf of Salerno*
Liverpool, Walker Art Gallery	*The Port of La Rochelle*
London, Guildhall Art Gallery	*The Great Tor, Oxwish Bay*
	On the Texel
	In the Gulf of Venice
	HMS Victory with the body of Nelson towed to Gibraltar (version)
London, National Maritime Museum	*Shakespeare's Cliff, Dover in 1849*
London, Royal Academy of Arts	*On the Scheldt near Leiskenshoeck squally day*
London, Tate Gallery	*Sketch for The Battle of Trafalgar*
	Entrance to the Zuyder Zee, Texel Island
	Lake Como
	The Canal of the Giudecca and the Church of the Gesuati, Venice
London, Victoria and Albert Museum	*A market boat on the Scheldt*
	View on the Scheldt
	Trajan's Arch, Ancona
	HMS Victory with the body of Nelson towed to Gibraltar (version)
	A Dutch dogger carrying away her sprit (On the Dogger Bank)
London, Wallace Collection	*Orford on the Ore, Suffolk*
	Beilstein on the Moselle
Manchester, City Art Gallery	*The last of the crew* or *After the wreck*
Penrhyn Castle (National Trust)	*Amalfi* (loan)
Sheffield, City Art Galleries	*The day after the wreck – a Dutch East Indiaman on shore in the Ooster Scheldt*
	The last of the crew
Sunderland, Art Gallery	*Lago di Garda*
	St Michael's Mount, Cornwall
Wolverhampton, Art Gallery	*Off Calais*

Puerto Rico
Ponce, Museo de Arte *Harbour of the River Bidassoa, Spain*

South Africa
Pietermaritzburg, Tatham Art *Rankel on the lake*
 Gallery

USA
Indianapolis, Museum of Art *Bligh Sands, Sheerness*

JAMES JACQUES JOSEPH TISSOT b. Nantes 1836–d. Buillon 1902

A Frenchman, who worked in Britain only for ten years, Tissot first studied
with Flandrin in Paris, where he met Whistler (q.v.) and Degas; he later
worked in Antwerp with Baron Leys. His early works are historical costume
pieces but by 1864 he began to paint modern life subjects and his success in
this field was confirmed after he settled in London in 1872 following his minor
involvement in the Paris Commune. Although Tissot refused Degas' invitation
in 1874 to exhibit at the first Impressionist exhibition, he was influenced by
these artists, particularly by Manet, but retained his distinctive polished finish
and the hint of anecdote in his subject matter. Despire Ruskin's criticism that
his works were 'mere coloured photographs of vulgar society', Tissot continued
his stylish paintings of London social life until, on the death of his mistress
and model Kathleen Newton in 1882, he returned to Paris and in later life
travelled in the Holy Land preparing a series of biblical designs.

Australia
Melbourne, National Gallery of *An interesting story (An unappreciative*
 Victoria *audience* or *Tracing the North-west*
 passage)
Sydney, National Gallery of New *The widower*
 South Wales

Belgium
Antwerp, Koninklijk Museum voor *The traveller*
 Schone Kunsten

Canada
Fredericton, Beaverbrook Art *A passing storm*
 Gallery
Hamilton, Art Gallery *Croquet*
 Martin Luther's doubts (Vespers)
Montreal, Museum of Fine Arts *October*
Ottawa, National Gallery of Canada *The letter*
Toronto, Art Gallery of Ontario *The milliner's shop (L'article de Paris)*
 Girl in an armchair (Mrs Kathleen New-
 ton or *The convalescent)*

France
Dijon, Musée des Beaux-Arts *Le déjeuner sur l'herbe*
 Reading in the park

	Japonaise au bain
Nantes, Musée des Beaux-Arts	*The Prodigal Son in modern life:*
	(4 pictures)
	The parting
	The return
	The fatted calf
	In a foreign country
	Tentative d'enlèvement
Paris, Louvre	*Portraits dans un parc*
	Young woman in a red jacket

Great Britain
Bristol, City Art Gallery	*Les adieux*
Cardiff, National Museum of Wales	*The parting*
Leeds, City Art Gallery	*The bridesmaid*
Liverpool, Walker Art Gallery	*Mrs Chapple Gill and her children*
London, Guildhall Art Gallery	*Too early*
	The last evening
London, National Portrait Gallery	*Frederick Burnaby*
London, Tate Gallery	*The ball on shipboard*
	Holiday
	Portsmouth Dockyard
	The Gallery of HMS Calcutta (Ports-mouth)
Manchester, City Art Gallery	*The Convalescent*
	Hush! (The concert)
Sheffield, City Art Galleries	*The convalescent*
Southampton, Art Gallery	*The captain's daughter*
	In church
Wakefield, City Art Gallery	*The Thames*
Wimpole Hall (National Trust)	*The shooting gallery*
	Sketch of a lady

Ireland, Republic of
| Dublin, National Gallery of Ireland | *Greenwich Pier* |
| | *Scene from The childhood of Christ in Egypt* |

New Zealand
| Auckland, City Art Gallery | *Still on top* |
| Dunedin, Public Art Gallery | *Waiting at the station* |

Puerto Rico
| Ponce, Museo de Arte | *In the Louvre (L'esthetique)* |

USA
Baltimore, Walters Art Gallery	*Leaving the confessional*
Buffalo, Albright-Knox Art Gallery	*L'ambiteuse*
Minneapolis, Institute of Art	*The journey of the Magi*
Newark, Newark Museum	*Return from Henley*

Philadelphia, Museum of Art	*Eugene Coppens de Fontenay*
Providence, Rhode Island School of Design	*The two friends*
	The Dance of Death
	In the Louvre
	The ladies of the cars
San Francisco, California Palace of the Legion of Honour	*Self-portrait*
Toledo, Museum of Art	*London visitors*
Worcester, Worcester Art Museum	*Gentleman in a coach*

HENRY WALLIS b. Sutton 1830–d. Croydon 1916

After training at the RA schools and in Paris, Wallis was influenced in the 1850s by the Pre-Raphaelites. During this period he produced his two important works; the intensely coloured and highly wrought *Chatterton* (1856) which was considered by Ruskin to be 'faultless', and *The Stonebreaker* (1857), a work of sombre social realism.

Great Britain

Birmingham, City Art Gallery	*The Stonebreaker*
	The death of Chatterton (version)
London, National Portrait Gallery	*Thomas Love Peacock*
London, Tate Gallery	*Chatterton* (*The death of Chatterton*)
	The room in which Shakespeare was born
	Landscape study
London, Victoria and Albert Museum	*Shakespeare's house, interior with stairs*
Stratford-upon-Avon, Royal Shakespeare Theatre Picture Gallery	*A sculptor's workshop, Stratford-upon-Avon, 1617*

USA

New Haven, Yale Center for British Art	*The death of Chatterton* (version)

EDWARD MATTHEW WARD b. Pimlico 1816–d. Windsor 1879

Ward trained at the RA schools and in Rome at the Academy of St Luke, where he won the Silver Medal for historical composition. He studied fresco briefly under Cornelius in Munich before returning to London in 1839. Ward's Royal Academy exhibits were very popular with the public. His brightly coloured anecdotal paintings were often taken from incidents in 17th- or 18th-century history and literature to which he contributed a domesticated intimacy. He gained a prize in the 1843 competition for the decoration of the Palace of Westminster and in 1855 completed eight scenes from British history in the corridor leading to the House of Commons.

Australia

Melbourne, National Gallery of Victoria	*Josephine signing the act of her divorce*

70 WARD

Germany, West (FDR)
Hamburg, Hamburger Kunsthalle — *The Greenwich pensioner: veteran of Aboukir*

Great Britain
Arbroath, Hospitalfield Trust — *Self-portrait at an easel with a model*
Bath, Victoria Art Gallery — *Napoleon Bonaparte in the prison of Nice, 1794*
Birmingham, City Art Gallery — *The last sleep of Argyll*
Burnley, Towneley Hall Art Gallery — *King James receiving news of the landing of William of Orange*
Bury, Art Gallery — *The fall of Clarendon*
Knebworth House, Hertfordshire — *Lord Lytton in his study*
Liverpool, Sudley Art Gallery — *Dr Johnson perusing the manuscript of The Vicar of Wakefield as a last resource for rescuing Goldsmith from the bailiffs*
Liverpool, Walker Art Gallery — *Dr Goldsmith and the apothecary*
Antechamber at Whitehall, 1685, during the last moments of Charles II
Jane Lane assisting Charles II to escape after the battle of Worcester
London, Apsley House — *Napoleon in prison as a young man*
London, National Portrait Gallery — *Daniel Maclise*
Thomas Babington Macaulay
London, Royal Academy of Arts — *Queen Elizabeth Woodville in the Sanctuary at Westminster*
London, Tate Gallery — *Dr Johnson in the ante-room of Lord Chesterfield, 1748*
The South Sea Bubble: a scene in Change Alley in 1720
Sketch for The disgrace of Lord Clarendon
James II in Whitehall receiving news of the landing of the Prince of Orange
Scene from 'David Garrick'
London, Victoria and Albert Museum — *Il fiammingo*
Charles II and Nell Gwynne
John Forster in his library
Manchester, City Art Gallery — *Byron's early love – a dream of Annesley Hall*
Newport, Art Gallery — *Defoe's manuscript of 'Robinson Crusoe'*
Osborne House, Isle of Wight — *Napoleon's tomb in Les Invalides*
Preston, Harris Art Gallery — *The royal family of France in the Prison of the Temple*
Sheffield, City Art Galleries — *Judge Jeffreys bullying Richard Barker*
Concealment of the fugitive by Alice Lisle after the Battle of Sedgemoor
The fall of Clarendon
Southampton, Art Gallery — *Leicester and Amy Robsart at Cumnor Hall*

Southport, Atkinson Art Gallery	*The Orphan of the Temple*
Stratford-upon-Avon, Royal Shake-speare Theatre Picture Gallery	*'The Taming of the Shrew'*
Sunderland, Art Gallery	*Anne Boleyn at the Queen's Stair, Tower of London*
York, City Art Gallery	*Hogarth's studio, 1739: holiday visit of the foundlings to view the portrait of Thomas Coram*

New Zealand

Dunedin, Public Art Gallery	*Benjamin West's first efforts in art*

South Africa

Cape Town, South African National Gallery	*Lord Chesterfield's ante-room, 1748*

JOHN WILLIAM WATERHOUSE b. Rome 1849-d. St John's Wood, London 1917

The son of an artist, Waterhouse trained as an assistant in his father's studio from 1868 and entered the RA schools in 1871. Initially under the influence of Alma-Tadema (q.v.), Waterhouse painted Greek and Roman subjects. Later, in figures from myth and literature displaying a personalized vision of femininity, Waterhouse developed an individual poetic style which combined the academic and neo-classical bias of Leighton with the romantic mediaeval-ism of Burne-Jones (qq.v.). In 1888, while painting *The Lady of Shalott* (Tate Gallery) he was briefly influenced by the *plein air* movement through his friendship with Frank Bramley (q.v.).

Australia

Adelaide, Art Gallery of South Australia	*Circe invidiosa - Circe poisoning the sea* *The favourites of the Emperor Honorius*
Melbourne, National Gallery of Victoria	*Ulysses and the Sirens*
Sydney, Art Gallery of New South Wales	*Diogenes*

Canada

Toronto, Art Gallery of Ontario	*'I am half sick of shadows': The Lady of Shalott* (seated figure)

Germany, West (FDR)

Darmstadt, Hessisches Landes-museum	*La Belle Dame sans Merci*

Great Britain

Aberdeen, Art Gallery	*The Danaides* *Penelope and her suitors*
Burnley, Towneley Hall Art Gallery	*The unwelcome companion (A street scene in Cairo)*

	Destiny
	Spanish tambourine girl
Cardiff, National Museum of Wales	*Fair Rosamond*
Falmouth, Museum and Art Gallery	*Study for The Lady of Shalott*
	The bouquet
Kirkcaldy, Museum and Art Gallery	*Dolce far niente*
Leeds, City Art Gallery	*The Lady of Shalott* (standing figure)
Liverpool, Walker Art Gallery	*Echo and Narcissus*
London, Fulham Public Library	*Study for Mariana in the south*
London, Royal Academy of Arts	*A mermaid*
London, Tate Gallery	*The Lady of Shalott* (figure in a boat)
	The magic circle
	Consulting the Oracle
	St Eulalia
Manchester, City Art Gallery	*Hylas and the nymphs*
Newcastle, Laing Art Gallery	*A Grecian flower stall*
Oldham, Art Gallery	*Circe offering the cup to Ulysses*
Plymouth, City Art Gallery	*The Hamadryad*
Port Sunlight, Lady Lever Art	*A tale from the Decameron*
Gallery	*The enchanted garden*
Preston, Harris Art Gallery	*Psyche entering Cupid's garden*
Rochdale, Art Gallery	*In the peristyle*
Sheffield, City Art Galleries	*Esther, the artist's wife*

GEORGE FREDERICK WATTS b. London 1817–d. Compton, Surrey 1904

Apprenticed to the sculptor Behnes in 1827, Watts entered the RA schools in 1835. After winning a prize for *Caractacus* in the 1843 Westminster Palace competition he travelled to Italy where he was befriended by and lived with Lord and Lady Holland (1843–47). Returning to London, from 1848–50 he produced a set of contemporary dress subjects which briefly link his work with the Social Realist movement. From 1850 to 1875 he was a permanent guest of Mr and Mrs Thoby Prinsep even while during 1864 he was briefly married to Ellen Terry. Following a second marriage in 1886 he lived in Compton near Guildford. Though often admired now for his fine portraits of famous contemporaries, Watts strove for recognition as a history painter, producing vast historical and mythological projects where his personal symbolism and allegory often confused his high-minded moral message. Following one-man exhibitions of his work at the Grosvenor Gallery in 1882 and in New York in 1884, he finally achieved widespread recognition for his grandiose moral schemes.

Australia

Adelaide, Art Gallery of South	*Love and Death*
Australia	*A. L. Tennyson*
Melbourne, National Gallery of	*Love and Death*
Victoria	

Canada

Montreal, Museum of Fine Arts	*Russell Gurney*
Ottawa, National Gallery of Canada	*Time, Death and Judgement*
Toronto, Art Gallery of Ontario	*The Sower of the systems*

France

Paris, Louvre	*Love and life*

Great Britain

Aberdeen, Art Gallery	*Orpheus and Eurydice*
	Eve tempted
	Self-portrait
Bedford, Cecil Higgins Art Gallery	*Sir Galahad*
Bournemouth, Russell-Cotes Art Gallery	*The cowl maketh not the monk*
Bristol, City Art Gallery	*Love and Death*
	Death and the Pale Horse
Buscot Park (National Trust)	*The wife of Pygmalion*
	The judgement of Paris
	The return of the dove
Cambridge, Fitzwilliam Museum	*Chaos*
	William Cavendish, 7th Duke of Devonshire
Carlisle, Art Gallery	*Mountain landscape*
	Study for When Poverty comes in at the door, love flies out at the window
Compton, Watts Gallery	*The wounded heron*
	Self-portrait aged 17
	Endymion
	The sower of the systems
	Fiesole
	Lady Holland on a day bed
	Found drowned
	Under a dry arch
	The sempstress
	The Irish famine
	Tasting the first oyster
	Dweller in the Innermost
	The denunciation of Cain
	The Sphinx
	Mammon
	Paolo and Francesca
	Chaos
	Olympus on Ida
	The court of Death
	For he had great possessions
	Love and Death
	Other oils, sketches and drawings

Edinburgh, National Gallery of Scotland	*Mischief* *Theophilos Kairis*
Falmouth, Art Gallery	*Britomart*
Huddersfield, Art Gallery	*Time, Death and Judgement*
Knebworth House, Hertfordshire	*1st Earl of Lytton*
Leeds, City Art Gallery	*Artemis*
Leicester, City Art Gallery	*Orlando pursuing the Fata Morgana*
Liverpool, Walker Art Gallery	*Orion* *Eve tempted* *Found drowned* (version)
London, Guildhall Art Gallery	*Ariadne in Naxos*
London, Leighton House	*Brynhylda* *Chaos*
London, National Portrait Gallery	*Matthew Arnold* *Thomas Carlyle* *Robert Browning* *Lord Leighton* *George Meredith* *John Stuart Mill* *William Morris* *John Everett Millais* *D. G. Rossetti* *A. C. Swinburne* *Cardinal Manning* *Ellen Terry*
London, St Paul's Cathedral	*Time, Death and Judgement*
London, Tate Gallery	*Echo* *A story from Boccaccio* *Self-portrait, 1864* *Hope* *The minotaur* *The all-pervading* *She shall be called woman* *The Spirit of Christianity* *Love and Death* *Life's illusions* *Sic transit* *Paolo and Francesca* *Lorenzo di Medici and two attendants*
London, Victoria and Albert Museum	
Manchester, City Art Gallery	*The Good Samaritan*
Norwich, Castle Museum	*The court of Death*
Nottingham, Castle Museum	*The Spirit of Christianity*
Oxford, Ashmolean Museum	*Evening* *Time, Death and Judgement* *The brethren of Saturn delivered* *The Carrara mountains from Pisa* *Little Red Riding Hood* *Thomas Carlyle*

Port Sunlight, Lady Lever Art Gallery	*The creation of Eve*
Southport, Atkinson Art Gallery	*The Misses Gurney*
Wightwick Manor (National Trust)	*Mrs Nassau Senior*
York, City Art Gallery	*Ararat*
	Progress

New Zealand

Dunedin, Public Art Gallery	*The eve of peace – Self-portrait c. 1863*

South Africa

Johannesburg, Art Gallery	*The rain – it raineth every day*

USA

Cambridge, Fogg Art Museum	*Sir Galahad*
Chicago, Art Institute of Chicago	*Time, Death and Judgement*
	A lamplight study – Herr Joachim
New York, Metropolitan Museum of Art	*Ariadne in Naxos*
Wilmington, Delaware Art Museum	*Jessamine*

THOMAS WEBSTER b. Pimlico 1800–d. Cranbrook 1886

Educated as a chorister at the Chapel Royal, Webster entered the RA schools in 1882. He worked at first as a portraitist, and from 1827 developed his characteristic pictures of children, in particular schoolboys, in a style modelled on 17th-century Flemish painting which had been introduced by Wilkie. His paintings of children at play were made popular by engravings, and he was elected RA in 1846. In 1856 Webster moved to Kent to join the colony of younger artists at Cranbrook, where he shared a studio with F. D. Hardy.

Great Britain

Aberdeen, Art Gallery	*The young volunteer*
Accrington, Haworth Art Gallery	*The village school*
	The post office
Brighouse, Art Gallery	*The gipsy*
Bristol, City Art Gallery	*Goodnight*
Bury, Art Gallery	*The boy with many friends*
Exeter, Royal Albert Memorial Museum	*William Miles*
Gateshead, Shipley Art Gallery	*The hop garden*
	Genius
Hull, Ferens Art Gallery	*Saying grace*
London, Guildhall Art Gallery	*The joke (The smile)*
	The frown
	See-saw
	The playground
London, Royal Academy of Arts	*The early lesson*
London, Tate Gallery	*The truant* or *Late for school*
	The artist's parents

	A letter from the Colonies
	A dame's school
London, Victoria and Albert	*Sickness and health*
Museum	*The lesson*
	Contrary winds
	Going to the fair
	The return from the fair
	The village choir
	Children at prayer
	Beating for recruits
	Reading the Scriptures
Preston, Harris Art Gallery	*A tea party*
Sheffield, City Art Galleries	*Roast pig*
	First steps
Southport, Atkinson Art Gallery	*Robbing the orchard*
Wolverhampton, Art Gallery	*Sunday afternoon*

New Zealand
Wanganui, Sarjeant Art Gallery *The new recruit*

USA
New Haven, Yale Center for British *The ring o'roses*
Art

JAMES ABBOTT McNEILL WHISTLER b. Lowell, Mass. 1843–d. London 1903

Whistler, who was brought up in his native America, and in Russia, in 1851 entered the West Point Military Academy. Subsequently his work for the US Coastal Survey taught him etching, and he decided to become an artist. He studied from 1855 in Paris where he became friendly with Poynter (q.v.) and Courbet and he settled in London in 1859. While his early work shows the influence of Courbet and Manet, in the 1860s he was increasingly impressed by Japanese art and decorated the Peacock Room 1876–77 (Freer Gallery). Whistler entitled his paintings 'arrangements', 'nocturnes' and 'symphonies' as a conscious rejection of the contemporary insistence on subject and as an assertion of his primary interest in the relationship of colours and tones. In 1887 *The falling rocket* was ridiculed by Ruskin who accused Whistler of 'flinging a pot of paint in the public's face'. Whistler sued and won a farthing damages. Whistler's lecture on art, 'Ten o'clock', was delivered in 1885 and subsequently published; his book *Art of Making Enemies* was published in 1890.

Canada
Ottawa, National Gallery of Canada *Study for Brown and gold: Lillie 'In our Alley'*

France
Paris, Louvre *Arrangement in grey and black, No. 1 – the artist's mother (Whistler's mother)*
Head of an old man

Great Britain

Birmingham, Barber Institute of Fine Arts	*Symphony in white, No. 3*
Cardiff, National Museum of Wales	*Blue and gold: St Mark's, Venice*
Edinburgh, National Gallery of Scotland	*Arrangement in grey and green: J. J. Cowan*
Glasgow, Art Gallery	*Arrangement in grey and black, No. 2 – Thomas Carlyle*
Glasgow, Hunterian Museum	*Battersea Reach from Lindsey House*
	Sketch for The balcony
	The morning after the Revolution, Valparaiso
	Annabel Lee
	Grey and silver: the Thames
	Blue and silver: screen with Old Battersea Bridge
	The gold ruff
	Harmony in flesh colour and black: Mrs Louise Jopling
	The Blue Girl: Connie Gilchrist
	Harmony in coral and blue: Miss Finch
	Harmony in red: lamplight
	Harmony in fawn colour and purple: Miss Milly Finch
	Harmony in blue and violet: Miss Finch
	Red and black: the fan
	Harmony in brown: the felt hat
	Harmony in black: Miss Ethel Philip
	Rose et argent: la jolie mutine
	Rose et or: la tulipe
	The brown hat: Miss Rosalind Birnie
	Brown gold: self-portrait
	Lillie, an oval
	Self-portrait 1896
	Little juniper bud – Lizzie Willis
	Collection of other sketches
Leeds, City Art Gallery	*Harmony in white and blue*
London, Tate Gallery	*Symphony in white, No. 2: The little white girl*
	Crepuscule in flesh colour and green: Valparaiso
	Pink and grey: three figures
	Miss May Alexander
	Nocturne: blue and silver – Chelsea
	Nocturne: blue and gold – Old Battersea Bridge
	Nocturne: blue and silver – Cremorne Lights

	Harmony in grey and green: Miss Cicely Alexander
	Nocturne: black and gold – the fire wheel
Oxford, Ashmolean Museum	*The shore, Pourville*
Sheffield, City Art Galleries	*The dancing lesson*

Ireland, Republic of

| Dublin, Municipal Gallery of Modern Art | *The artist's studio* |
| | *Sketch of Walter Sickert* |

Netherlands

| Amsterdam, Rijksmuseum | *Arrangement in yellow and grey – Effie Deans* |

USA

Boston, Isabella Stewart Gardner Museum	*Harmony in blue and silver – Trouville*
	Nocturne: blue and silver – Battersea Reach
Boston, Museum of Fine Arts	*The last of old Westminster*
	Harmony in flesh colour and red
	Nocturne in blue and silver: the lagoon, Venice
	Street in old Chelsea
Cambridge, Fogg Art Museum	*Nocturne: grey and gold – Chelsea snow*
	Maud Franklin
	Harmony in grey and peach colour Cremorne No. 1
	Nocturne in blue and silver
	Nocturne: black and gold – rag shop, Chelsea
	The little white sofa
	Green and violet: Mrs Walter Sickert
	Self-portrait, 1893/94
	Brown and gold: Lillie 'In our Alley'
Chicago, Art Institute of Chicago	*Grey and silver: Battersea Reach*
	Whistler in his studio
	Trouville
	Dr William McNeill Whistler
	Study for Arrangement in grey and black, No. 2 – Thomas Carlyle
	Nocturne: blue and gold – Southampton Water
	Arrangement in flesh colour and brown: Arthur J. Eddy
	Violet and silver – a deep sea
Cincinnati, Art Museum	*Arrangement in pink, red and purple*
Cincinnati, Taft Museum	*At the piano*
Detroit, Institute of Arts	*Arrangement in grey: self-portrait 1872*
	Nocturne in black and gold: the falling rocket

Hartford, Wadsworth Atheneum	*Alone with the tide – the coast of Brittany*
Indianapolis, Museum of Art	*Nocturne*
New York, Frick Collection	*Symphony in green and grey: the ocean*
	Symphony in flesh colour and pink: Mrs Frances Leyland
	Arrangement in brown and black: Miss Rosa Corder
	Harmony in pink and grey: Lady Neux
	Arrangement in black and gold: Comte Robert de Montesquiou-Fezensac
New York, Metropolitan Museum of Art	*Cremorne Gardens, No. 2*
	Nocturne in Black and Gold: the gardens
	Arrangement in black, No. 3: Sir Henry Irving as Phillip II
	Harmony in yellow and gold: the Gold Girl, Connie Gilchrist
	Arrangement in flesh colour and black: Theodore Duret
Philadelphia, Museum of Art	*Purple and rose: the Lange Leizen of the Six Marks*
	Nocturne: grey and silver
	Arrangement in black: La dame en brodequin jaune, Lady Archibald Campbell
Providence, Rhode Island School of Design, Museum of Art	*Harmony in blue; the duet*
	Chelsea shop
Toledo, Museum of Art	*Crepuscule in opal: Trouville*
Washington, Freer Gallery	*Self-portrait with hat, 1857–58*
	Caprice in purple and gold: the golden screen
	Harmony in green and rose: the music room
	The Thames in ice
	Blue and silver: Trouville
	Nocturne: Cremorne Gardens, No. 3
	Nocturne: Trafalgar Square, snow
	Symphony in grey: early morning, Thames
	Symphony in white and red
	Symphony in blue and pink
	Nocturne: blue and silver, Battersea Reach
	Variation in flesh colour and green: the balcony
	Nocturne: blue and silver – Bognor
	Nocturne in blue and gold, Valparaiso Bay
	The white symphony: three girls
	Arrangement in black: F. R. Leyland
	Harmony in blue and gold: the Peacock Room – entire decorated room containing: *Rose and silver: La princesse du pays de la porcelaine*

Nocturne: grey and silver – Chelsea Embankment, winter
Red and pink: La petite Mephisto
Green and silver: the Devonshire cottages
Harmony in blue and gold: The little blue girl
Purple and gold: Phryne the superb builder of temples
Charles L. Freer
Collection of small sketches

Washington, National Gallery of Art *Grey and silver – Chelsea Wharf*
Symphony in white, No. 1 – the white girl
George W. Vanderbilt

Worcester, Art Museum *Sketch for rose and silver: la princesse du pays de la porcelaine*
Arrangement in black and brown: the fur jacket

WILLIAM FREDERICK YEAMES b. Taganrog 1835–d. Teignmouth 1918

Born in Southern Russia where his father was consul, Yeames studied with Scharf in London and in Italy from 1852–58. He began exhibiting at the Royal Academy from 1859 and as a highly successful member of the St John's Wood Clique, a group of artists who included H. S. Marks, Story and F. Walker, he specialized in scenes of historical genre. His popular painting *'And when did you last see your father?'* has often been viewed as the epitome of Victorian story-telling in paint.

Great Britain and Northern Ireland
Aberdeen, Art Gallery *Self-portrait*
Belfast, Ulster Museum *Choir boys*
Bristol, City Art Gallery *Defendant and counsel*
Glasgow, Art Gallery *Prisoners of war*
Hartlepool, Gray Art Gallery *Cherry ripe*
Liverpool, Walker Art Gallery *'And when did you last see your father?'*
London, Royal Academy of Arts *La bigolante*
London, Tate Gallery *Death of Amy Robsart*
Manchester, City Art Gallery *Prince Arthur and Hubert*
Nottingham, Castle Museum *Death of Amy Robsart*
Preston, Harris Art Gallery *The palace of the Podezza*
Sheffield, City Art Galleries *Lady Jane Grey in the Tower*
Wolverhampton, Art Gallery *Peace and war* or *Here we go round the mulberry bush*
Amy Robsart

New Zealand
Nelson, Bishop Suter Memorial Art Gallery *The dawn of the Reformation* (version)

TOPOGRAPHICAL INDEX

Note: National Trust properties and private houses are often only open during the summer months and for a few other institutions (marked with an asterisk) viewing by appointment is necessary. The reader is reminded that the limited exhibition space in many art galleries means that less popular paintings may be kept in storage and any request to see a specific item should be made in advance of the visit.

AUSTRALIA

Adelaide, *Art Gallery of South Australia*
Alma-Tadema, Burne-Jones, Clausen, Collier, Faed, Landseer, Leighton, Palmer, Poynter, Waterhouse, Watts

Brisbane, *Queensland Art Gallery*
Burne-Jones, Clausen

Geelong, *Victoria Art Gallery*
Faed, Forbes, Long

Hobart, *Tasmanian Museum and Art Gallery*
Poynter

Melbourne, *National Gallery of Victoria*
Alma-Tadema, Bonington, Brown, Burne-Jones, Butler, Clausen, Dicksee, Dyce, Faed, Frith, Herbert, Holl, Hughes, Hunt, Landseer, Lewis, Long, Millais, Orchardson, Palmer, Pettie, Stanfield, Tissot, Ward, Waterhouse, Watts

Perth, *Western Australian Art Gallery*
Clausen, Frith

Sydney, *Art Gallery of New South Wales*
Alma-Tadema, Brown, Burne-Jones, Clausen, Collier, Danby, Fildes, Forbes, Leighton, Long, Millais, Poynter, Tissot, Waterhouse

BELGIUM

Antwerp, *Koninklijk Museum voor Schone Kunsten*
Alma-Tadema, Tissot

CANADA

Fredericton, New Brunswick, *Beaverbrook Art Gallery*
Faed, Frith, Orchardson, Tissot

Hamilton, Ontario, *Art Gallery*
Tissot

Montreal, *Museum of Fine Arts*
Bonington, Faed, Pettie, Poynter, Tissot, Watts

Ottawa, *Canadian War Museum*
Clausen

Ottawa, *National Gallery of Canada*
Bonington, Egg, Frith, Hunt, Leighton, Lewis, Millais, Palmer, Rossetti, Tissot, Watts, Whistler

Toronto, *Art Gallery of Ontario*
Clausen, Hughes, Tissot, Waterhouse, Watts

Vancouver, *Art Gallery*
Frith, Leighton

FRANCE

Dijon, *Musée des Beaux-Arts*
Tissot

Nantes, *Musée des Beaux-Arts*
Tissot

Paris, *Musée du Louvre*
Bonington, Tissot, Watts, Whistler

GERMANY, WEST (FDR)

Bonn, *Rheinisches Landesmuseum*
Stanfield

Darmstadt, *Hessisches Landesmuseum*
Waterhouse

Frankfurt am Main, *Stadelsches Kunstinstitut*
Leighton

Hamburg, *Hamburger Kunsthalle*
Alma-Tadema, Dyce, Faed, Fildes, Herbert, Landseer, Leighton, Maclise, Millais, Pettie, Redgrave, Rossetti, Stanfield, Ward

Stuttgart, *Staatsgalerie*
Burne-Jones

GREAT BRITAIN and NORTHERN IRELAND

Aberdeen, *Art Gallery*
Alma-Tadema, Brett, Brown, Clausen, Dicksee, Dyce, Faed, Fildes, Forbes, Frith, Holl, Hughes, Hunt, Landseer, Leighton, Long, Millais, Orchardson, Palmer, Pettie, Poynter, Rossetti, Waterhouse, Watts, Webster, Yeames

Accrington, *Haworth Art Gallery*
Collins, Faed, Leighton, Webster

Anglesey Abbey, Lode, Cambridgeshire, *National Trust*
Bonington, Landseer, Leighton, Martin

Arbroath, Tayside, *Hospitalfield House** (Patrick Allan Fraser Hospitalfield Trust)
Egg, Frith, Pettie, Ward

Barnsley, *Cooper Art Gallery*
Landseer, Leighton

Bateman's, Burwash, East Sussex, *National Trust*
Collier, Poynter

Bath, *Victoria Art Gallery*
Danby, Forbes, Leighton, Long, Stanfield, Ward

Bedford, *Cecil Higgins Art Gallery*
Dadd, Dyce, Eastlake, Leighton, Lewis, Moore, Watts

Belfast, *Ulster Museum*
Clausen, Frith, Leslie, Orchardson, Stanfield, Yeames

Beverley, Humberside, *Art Gallery*
Hughes

Birkenhead, *Williamson Art Gallery*
Alma-Tadema, Burne-Jones, Collier, Eastlake, Herbert, Lewis, Moore, Pettie, Stanfield

Birmingham, *Barber Institute of Fine Arts*, University of Birmingham
Orchardson, Rossetti, Whistler

Birmingham, *City Art Gallery*
Alma-Tadema, Brett, Brown, Burne-Jones, Clausen, Collins, Dyce, Eastlake, Egg, Forbes, Frith, Holl, Hughes, Hunt, Landseer, Leighton, Lewis, Martin, Martineau, Millais, Moore, Palmer, Poynter, Redgrave, Rossetti, Wallis, Ward

Blackburn, *Art Gallery*
Collier, Faed, Leighton, Long, Moore

Blackpool, *Grundy Art Gallery*
Collier, Dicksee, Faed, Forbes, Grimshaw, Leslie, Millais

Bournemouth, *Russell-Cotes Museum and Art Gallery*
Collier, Collins, Fildes, Frith, Grimshaw, Hughes, Landseer, Leighton, Long, Moore, Orchardson, Poynter, Rossetti, Watts

Bradford, *Cartwright Hall*
Brown, Clausen, Collier, Dicksee, Forbes, Grimshaw, Long

Brighouse, West Yorkshire, *Art Gallery*
Collins, Egg, Faed, Frith, Grimshaw, Leighton, Leslie, Millais, Redgrave, Webster

Brighton, *Museum and Art Gallery*
Alma-Tadema, Brett, Dyce, Faed, Forbes, Stanfield

Bristol, *City Art Gallery*
Alma-Tadema, Burne-Jones, Clausen, Danby, Dicksee, Faed, Forbes, Holl, Hughes, Leighton, Long, Millais, Pettie, Poynter, Tissot, Watts, Webster, Yeames

Broughty Ferry, nr Dundee, *James Orchar Art Gallery*
Faed, Lewis, Orchardson, Pettie

Burnley, *Towneley Hall Art Gallery*
Alma-Tadema, Burne-Jones, Dicksee, Landseer, Long, Poynter, Ward, Waterhouse

Bury, *Art Gallery*
Butler, Clausen, Collins, Faed, Herbert, Landseer, Maclise, Moore, Stanfield, Ward, Webster

Buscot Park, Faringdon, Oxfordshire, *National Trust*
Alma-Tadema, Brown, Burne-Jones, Landseer, Leighton, Millais, Rossetti, Watts

Cambridge, *Fitzwilliam Museum*
Alma-Tadema, Bonington, Brett, Brown, Clausen, Dadd, Frith, Hughes, Hunt, Leighton, Lewis, Martin, Millais, Moore, Palmer, Pettie, Rossetti, Stanfield, Watts

Cardiff, *City Hall*
Fildes

Cardiff, *National Museum of Wales*
Alma-Tadema, Burne-Jones, Clausen, Dicksee, Forbes, Frith, Maclise, Millais, Rossetti, Tissot, Waterhouse, Whistler

Carlisle, *Art Gallery*
Brown, Burne-Jones, Hughes, Maclise, Moore, Palmer, Rossetti, Watts

Chatsworth, Derbyshire, *Duke of Devonshire*
Collins, Eastlake, Palmer

Cheltenham, *Art Gallery*
Collins

Compton, nr Guildford, *Watts Gallery*
Burne-Jones, Leighton, Moore, Watts

Coventry, *Herbert Art Gallery*
Collier, Hunt, Landseer, Poynter

Darlington, *Art Gallery*
Collier

Derby, *Art Gallery*
Frith

Dundee, *City Art Gallery*
Holl, Millais, Orchardson, Pettie, Rossetti

Edinburgh, *John Knox's House*
Dyce

Edinburgh, *National Gallery of Scotland*
Bonington, Clausen, Dyce, Landseer, Martin, Millais, Moore, Orchardson, Pettie, Rossetti, Watts, Whistler

Edinburgh, *Scottish National Portrait Gallery*
Dyce, Faed, Orchardson, Pettie

Egham, Surrey, *Royal Holloway College*,* University of London
Brett, Collins, Faed, Fildes, Frith, Holl, Landseer, Long, Maclise, Millais, Pettie, Stanfield

Exeter, *Royal Albert Memorial Museum and Art Gallery*
Brett, Danby, Eastlake, Faed, Forbes, Frith, Holl, Long, Poynter, Webster

Falmouth, *Art Gallery*
Burne-Jones, Waterhouse, Watts

Gateshead, *Shipley Art Gallery*
Collins, Eastlake, Grimshaw, Redgrave, Stanfield, Webster

Glasgow, *Art Gallery and Museum*
Alma-Tadema, Brett, Brown, Burne-Jones, Clausen, Collier, Dyce, Eastlake, Faed, Frith, Martin, Millais, Moore, Orchardson, Pettie, Rossetti, Whistler, Yeames

Glasgow, *Hunterian Museum,* University of Glasgow
Whistler

Gloucester, *Art Gallery*
Collier, Grimshaw

Grasmere, Cumbria, *Village Hall*
Bramley

Greenock, Strathclyde, *Art Gallery*
Leighton, Orchardson

Harrogate, North Yorkshire, *Art Gallery*
Egg, Frith, Grimshaw

Hartlepool, Cleveland, *Gray Art Gallery*
Forbes, Maclise, Yeames

Huddersfield, *Art Gallery*
Clausen, Grimshaw, Watts

Hull, *Ferens Art Gallery*
Bonington, Butler, Clausen, Dicksee, Forbes, Grimshaw, Leighton, Pettie, Stanfield, Webster

Ipswich, *Christchurch Mansion*
Collier, Forbes

Kilmarnock, Strathclyde, *Dick Institute*
Alma-Tadema, Leighton, Millais

Kirkcaldy, Fife, *Art Gallery*
Faed, Martin, Orchardson, Waterhouse

Knebworth House, Hertfordshire, *The Hon. David Lytton Cobbold*
Maclise, Ward, Watts

Leeds, *City Art Gallery*
Butler, Clausen, Collins, Dadd, Dicksee, Grimshaw, Holl, Hunt, Leighton, Maclise, Millais, Palmer, Pettie, Tissot, Waterhouse, Watts, Whistler

Leicester, *City Art Gallery*
Burne-Jones, Dicksee, Dyce, Egg, Faed, Frith, Hunt, Leighton, Maclise, Stanfield, Watts

Lincoln, *Usher Art Gallery*
Bramley, Clausen, Collier, Hughes

Liverpool, *Sudley Art Gallery,* Emma Holt Bequest
Alma-Tadema, Bonington, Burne-Jones, Collins, Dyce, Faed, Fildes, Frith, Herbert, Hunt, Landseer, Leighton, Millais, Rossetti, Stanfield, Ward

Liverpool, *Walker Art Gallery*
Bramley, Brett, Brown, Burne-Jones, Clausen, Collins, Dadd, Dicksee, Egg, Faed, Fildes, Forbes, Frith, Herbert, Holl, Hughes, Hunt, Landseer, Leighton, Leslie, Maclise, Martin, Martineau, Millais, Moore, Orchardson, Pettie, Poynter, Rossetti, Stanfield, Tissot, Ward, Waterhouse, Watts, Yeames

Llandaff, *Cathedral*
Rossetti

London, *Apsley House,* Wellington Museum
Landseer, Leslie, Ward

London, *Fulham Public Library*,* London Borough of Hammersmith
Alma-Tadema, Burne-Jones, Moore, Waterhouse

London, *Guildhall Art Gallery**
Alma-Tadema, Brett, Collier, Collins, Dicksee, Dyce, Egg, Faed, Frith, Grimshaw, Herbert, Holl, Hunt, Landseer, Leighton, Maclise, Millais, Moore, Poynter, Rossetti, Stanfield, Tissot, Watts, Webster

London, *Imperial War Museum*
Clausen, Forbes

London, *Kenwood,* Iveagh Bequest
Landseer

London, *Leighton House*
Burne-Jones, Clausen, Leighton, Millais, Watts

London, *National Maritime Museum*
Brett, Eastlake, Orchardson, Stanfield

London, *National Portrait Gallery*
Alma-Tadema, Collier, Dyce, Egg, Frith, Holl, Hughes, Hunt, Landseer, Leighton, Leslie, Long, Maclise, Millais, Orchardson, Redgrave, Tissot, Wallis, Ward, Watts

London, *Royal Academy of Arts*
Alma-Tadema, Bramley, Clausen, Collins, Dicksee, Dyce, Eastlake, Egg, Faed, Fildes, Forbes, Frith, Herbert, Holl, Landseer, Leighton, Leslie, Lewis, Long, Maclise, Millais, Orchardson, Pettie, Poynter, Redgrave, Stanfield, Ward, Waterhouse, Webster, Yeames

London, *St Paul's Cathedral*
Hunt, Watts

London, *St Stephen's Hall, Palace of Westminster*
Clausen

London, *Sir John Soane's Museum*
Danby, Eastlake

London, *Tate Gallery*
Alma-Tadema, Bonington, Bramley, Brett, Brown, Burne-Jones, Butler, Clausen, Collier, Collins, Dadd, Danby, Dicksee, Dyce, Eastlake, Egg, Faed, Fildes, Forbes, Frith, Grimshaw, Herbert, Holl, Hughes, Hunt, Landseer, Leighton, Leslie, Lewis, Maclise, Martin, Martineau, Millais, Moore, Orchardson, Palmer, Pettie, Poynter, Redgrave, Rossetti, Stanfield, Tissot, Wallis, Ward, Waterhouse, Watts, Webster, Whistler, Yeames

London, *Victoria and Albert Museum*
Alma-Tadema, Bonington, Burne-Jones, Clausen, Collins, Dadd, Danby, Eastlake, Faed, Frith, Holl, Hughes, Landseer, Leighton, Leslie, Lewis, Long, Maclise, Martin, Millais, Moore, Palmer, Poynter, Redgrave, Rossetti, Stanfield, Wallis, Ward, Watts, Webster

London, *Wallace Collection*
Bonington, Landseer, Stanfield

Manchester, *City Art Gallery*
Alma-Tadema, Bonington, Brett,
Brown, Burne-Jones, Butler, Clau-
sen, Collins, Dicksee, Eastlake, Egg,
Faed, Fildes, Forbes, Frith, Hughes,
Hunt, Landseer, Leighton, Lewis,
Maclise, Martineau, Millais, Moore,
Orchardson, Pettie, Poynter, Ros-
setti, Stanfield, Tissot, Ward, Water-
house, Watts, Webster, Yeames

Manchester, *Town Hall*
Brown

Manchester, *Whitworth Art Gallery*,
University of Manchester
Lewis, Palmer

Merthyr Tydfil, Mid Glamorgan,
Cyfantha Castle Art Gallery
Collier

Newcastle upon Tyne, *Laing Art
Gallery*
Alma-Tadema, Burne-Jones, Clau-
sen, Dadd, Faed, Forbes, Grimshaw,
Hughes, Hunt, Landseer, Lewis,
Maclise, Martin, Palmer, Poynter,
Waterhouse

Newport, Gwent, *Art Gallery*
Dadd, Forbes, Lewis, Poynter, Ward

Northampton, *Central Museum and
Art Gallery*
Lewis

Norwich, *Castle Museum*
Burne-Jones, Watts

Nottingham, *Castle Museum*
Bonington, Brett, Brown, Butler,
Clausen, Collins, Dyce, Frith, Land-
seer, Orchardson, Rossetti, Watts,
Yeames

Oldham, *Art Gallery*
Clausen, Collier, Forbes, Long, Mil-
lais, Waterhouse

Osborne House, Isle of Wight,
H.M. the Queen
Dyce, Eastlake, Ward

Oxford, *Ashmolean Museum*
Alma-Tadema, Bonington, Brown,
Burne-Jones, Clausen, Dadd, Egg,
Faed, Frith, Hughes, Hunt, Land-
seer, Leighton, Lewis, Martineau,
Millais, Moore, Palmer, Pettie,
Watts, Whistler

Oxford, *Keble College Chapel*
Hunt

**Penrhyn Castle, Bangor,
Gwynedd,** *National Trust*
Herbert, Stanfield

Perth, *Museum and Art Gallery*
Millais

Petworth House, West Sussex,
National Trust
Leslie

Plymouth, *City Art Gallery*
Brett, Burne-Jones, Collier, Forbes,
Waterhouse

Port Sunlight, Wirral, *Lady Lever
Art Gallery*
Alma-Tadema, Brown, Burne-
Jones, Dicksee, Fildes, Hughes,
Hunt, Landseer, Leighton, Millais,
Orchardson, Rossetti, Waterhouse,
Watts

Preston, *Harris Museum and Art
Gallery*
Alma-Tadema, Clausen, Collins,
Danby, Dicksee, Egg, Fildes, Forbes,
Frith, Grimshaw, Herbert, Hughes,
Hunt, Landseer, Leighton, Leslie,
Lewis, Maclise, Palmer, Ward,
Waterhouse, Webster, Yeames

Rochdale, *Art Gallery*
Clausen, Waterhouse

St Helier, Jersey, *Fort Regent*
Millais

Scarborough, *Art Gallery*
Grimshaw, Leighton

Sheffield, *City (Graves and Mappin)
Art Galleries* (most British pictures
exhibited at the latter)
Bonington, Brett, Burne-Jones, Collins, Danby, Dicksee, Egg, Faed,
Frith, Grimshaw, Hughes, Hunt,
Landseer, Leslie, Lewis, Long, Maclise, Millais, Moore, Orchardson,
Pettie, Stanfield, Tissot, Ward,
Waterhouse, Webster, Whistler,
Yeames

Southampton, *Art Gallery*
Brown, Burne-Jones, Collier, Dicksee, Dyce, Holl, Hunt, Martin, Millais, Orchardson, Poynter, Tissot,
Ward

Southport, *Atkinson Art Gallery*
Collier, Collins, Faed, Ward, Watts,
Webster

South Shields, *Art Gallery*
Frith

Stratford-upon-Avon, *Royal Shakespeare Theatre Picture Gallery*
Brown, Dicksee, Leslie, Maclise, Millais, Pettie, Wallis, Ward

Stoke-on-Trent, *Art Gallery*
Clausen, Collier

Sunderland, *Art Gallery*
Brett, Collier, Faed, Herbert, Landseer, Lewis, Stanfield, Ward

Wakefield, *City Art Gallery*
Collier, Grimshaw, Tissot

**Wallington Hall, Cambo,
Northumberland,** *National Trust*
Burne-Jones, Leighton

Walthamstow, *William Morris
Gallery*
Alma-Tadema, Brown, Burne-Jones,
Hughes, Leighton

Wightwick Manor, Wolverhampton, *National Trust*
Brett, Brown, Burne-Jones, Millais,
Rossetti, Watts

Wimpole Hall, Nr Cambridge,
National Trust
Tissot

Woburn Abbey, Bedfordshire,
Duke of Bedford
Eastlake

Wolverhampton, *Art Gallery*
Collier, Collins, Faed, Frith, Herbert, Landseer, Leslie, Long, Maclise, Orchardson, Pettie, Poynter,
Redgrave, Stanfield, Webster,
Yeames

Worcester, *Art Gallery*
Collier

York, *City Art Gallery*
Dadd, Danby, Martin, Moore,
Ward, Watts

GREECE

Athens, *Benaki Museum*
Bonington, Eastlake

IRELAND, REPUBLIC OF (EIRE)

Cork, *Crawford Municipal Art Gallery*
Bramley, Maclise

Dublin, *Municipal Gallery of Modern
Art*
Burne-Jones, Moore, Orchardson,
Whistler

Dublin, *National Gallery of Ireland*
Brett, Collier, Collins, Danby, Landseer, Maclise, Millais, Tissot

NETHERLANDS

Amsterdam, *Historisches Museum*
Alma-Tadema

Amsterdam, *Rijksmuseum*
Alma-Tadema, Whistler

Dordrechts, *Dordrechts Museum*
Alma-Tadema

Groningen, *Groninger Museum voor Stad en Lande*
Alma-Tadema

The Hague, *Haags Gemeentemuseum*
Alma-Tadema

The Hague, *Rijksmuseum H.W. Mesdag*
Alma-Tadema

Laren, nr Hilversum, *Singer Museum*
Alma-Tadema

Leeuwarden, Friesland, *Fries Museum*
Alma-Tadema

Soestdijk, nr Utrecht, *Koninklijk Huisarchief, Soestdijk Palace*
Alma-Tadema

NEW ZEALAND

Auckland, *City Art Gallery*
Alma-Tadema, Bramley, Burne-Jones, Clausen, Collier, Forbes, Frith, Leighton, Lewis, Maclise, Millais, Tissot

Christchurch, *Robert McDougall Art Gallery*
Leighton

Dunedin, *Public Art Gallery*
Burne-Jones, Forbes, Frith, Lewis, Tissot, Ward, Watts

Nelson, *Bishop Suter Memorial Art Gallery*
Yeames

Wanganui, *Sarjeant Art Gallery*
Burne-Jones, Webster

Wellington, *National Gallery of New Zealand*
Clausen, Poynter

PUERTO RICO

Ponce, *Museo de Arte*
Burne-Jones, Hunt, Leighton, Millais, Rossetti, Stanfield, Tissot

SOUTH AFRICA

Cape Town, *South African National Gallery*
Bramley, Clausen, Maclise, Orchardson, Pettie, Ward

Durban, *Museum and Art Gallery*
Bramley, Butler, Clausen, Faed, Forbes, Frith

East London, *Ann Bryant Art Gallery*
Eastlake

Johannesburg, *Art Gallery*
Alma-Tadema, Bonington, Brett, Brown, Clausen, Frith, Hunt, Landseer, Lewis, Maclise, Martineau, Millais, Moore, Orchardson, Rossetti, Watts

Pietermaritzburg, *Tatham Art Gallery*
Clausen, Stanfield

SWITZERLAND

Geneva, *Musée d'Art et d'Histoire*
Danby

USA

Baltimore, Maryland, *Walters Art Gallery*
Alma-Tadema, Millais, Tissot

Boston, Massachusetts, *Isabella Stewart Gardner Museum*
Rossetti, Whistler

Boston, Massachusetts, *Museum of Fine Arts*
Alma-Tadema, Bonington, Burne-Jones, Leighton, Leslie, Martin, Rossetti, Tissot, Whistler

Buffalo, N.Y., *Albright-Knox Art Gallery*
Tissot

Cambridge, Massachusetts, *Fogg Art Museum,* Harvard University
Alma-Tadema, Brown, Burne-Jones, Hunt, Millais, Rossetti, Watts, Whistler

Chicago, Illinois, *Art Institute of Chicago*
Bonington, Leslie, Rossetti, Watts, Whistler

Cincinnati, Ohio, *Art Museum*
Alma-Tadema, Whistler

Cincinnati, Ohio, *Taft Museum*
Alma-Tadema, Whistler

Detroit, Michigan, *Detroit Institute of Arts*
Landseer, Whistler

Fort Worth, Texas, *Kimbell Art Museum*
Leighton

Hartford, Connecticut, *Wadsworth Atheneum*
Burne-Jones, Hunt, Landseer, Whistler

Indianapolis, Indiana, *Museum of Art*
Brett, Stanfield, Whistler

Louisville, Kentucky, *J. B. Speed Museum*
Landseer

Malibu, California, *J. Paul Getty Museum*
Alma-Tadema, Millais

Milwaukee, Wisconsin, *Milwaukee Art Center*
Alma-Tadema, Leighton

Minneapolis, Minnesota, *Minneapolis Institute of Art*
Dyce, Leighton, Millais, Tissot

New Haven, Connecticut, *Yale Center for British Art*
Bonington, Burne-Jones, Collins, Dadd, Danby, Eastlake, Egg, Landseer, Leighton, Lewis, Martin, Moore, Palmer, Redgrave, Wallis, Webster

New Haven, Connecticut, *Yale University Art Gallery*
Alma-Tadema, Millais

Newark, New Jersey, *Newark Museum*
Tissot

New York, N.Y., *Frick Collection*
Whistler

New York, N.Y., *Metropolitan Museum of Art*
Bonington, Burne-Jones, Leighton, Leslie, Millais, Watts, Whistler

Philadelphia, Pennsylvania, *Atheneum of Philadelphia*
Leslie

Philadelphia, Pennsylvania,
Pennsylvania Academy of Fine Arts
Leslie

Philadelphia, Pennsylvania,
Pennsylvania Museum of Art
Alma-Tadema, Bonington, Palmer,
Tissot, Whistler

Poughkeepsie, N.Y., *Vasser College*
Art Gallery
Alma-Tadema, Eastlake

Princeton, New Jersey, *Art*
Museum, Princeton University
Leighton

Providence, Rhode Island, *Rhode*
Island School of Design, Museum of
Art
Eastlake, Frith, Tissot, Whistler

Richmond, Virginia, *Virginia*
Museum of Fine Arts
Bonington

San Francisco, California, *Califor-*
nia Palace of the Legion of Honour
Tissot

San Marino, California, *H. E.*
Huntington Library and Art Gallery
Dadd, Lewis

Toledo, Ohio, *Toledo Museum of Art*
Hughes, Maclise, Martin, Palmer,
Rossetti, Tissot, Whistler

Washington, D.C., *Freer Gallery*
Whistler

Washington, D.C., *National Gallery*
of Art
Whistler

Washington, D.C., *Maryhill Museum*
of Fine Arts
Leighton

Williamstown, Massachusetts,
Sterling and Francine Clark Art
Institute
Alma-Tadema, Collins, Moore

Wilmington, Delaware, *Delaware*
Art Museum
Brown, Burne-Jones, Hunt, Millais,
Moore, Poynter, Rossetti, Watts

Worcester, Massachusetts,
Worcester Art Museum
Tissot, Whistler